書象

典則潮風·蔡明讚現代書藝

部長序

　　書法具有東方藝術獨特的表現形式，常民化的書寫也是許多臺灣民眾成長過程的共同記憶。《書法教育月刊》社長蔡明讚先生，在深厚傳統技法的基礎上創新書藝，不僅藝術成就獲得肯定，對於書法教育的長期付出與貢獻，更是備受推崇。

　　出生於臺灣桃園的世代務農之家，蔡明讚先生一九七〇年代負笈臺北師專，投入書法教育推展工作四十年，報導書壇活動訊息、撰寫國語日報專欄、編輯書法教材、出版國民小學書法課本，同時以籌辦比賽、展覽、研討等多元方式，致力推廣書法藝術文化。歷任中華民國書法教育學會秘書長、副理事長、理事長，其中協助高雄明宗國小辦理「明宗獎」，支持該校「明宗書法藝術館」各項展覽資源，成為南臺灣書法藝術展示與交流重鎮，是生活美學向下紮根，縮短城鄉文化差距的具體實踐。

　　蔡明讚先生的書藝入古出新，融會帖學與碑學審美，大量書寫自作詩，彰顯文人性的表現內涵，同時借鏡日本墨象前衛、西方抽象表現主義，反映當代藝術潮流的視覺造形和抽象意趣。本部所屬國立國父紀念館中山國家畫廊本次舉辦《典則·潮風——蔡明讚書藝展》，是對書法教育工作者長期奉獻耕耘的致意，也誠摯歡迎各界人士前往參觀，一覽當代書法美學的銳變與新貌。

文化部 部長

李永得

Preface by Minister

Calligraphy is a unique expression of oriental art. The writing of common people is also the shared memory of many Taiwanese people in the growing process. The president of the monthly, Calligraphy Education, Mr. Tsai Ming-tzann, makes innovations of calligraphy art on the basis of the solid traditional skills. Not only his art achievement but also his long devotion and contribution to calligraphy education are highly respected.

Born in a farming family in Taoyuan, Taiwan, Mr. Tsai Ming-tzann studied in Taipei Teachers' College in the 1970s and has been devoted to the promotions of calligraphy education for forty years. He reported the activities in the calligraphy circle, wrote the column on Mandarin Daily News, edited the calligraphy materials, published the elementary school calligraphy textbooks, and at the same time promoted calligraphy art and culture by holding competitions, exhibition, and seminars. He served as the secretary-general, vice chairman, and chairman of The Republic of Chinese Society for Calligraphy Education. He assisted Ming Zong Elementary School in Kaohsiung in holding the "Ming Zong Award" and supported the school's resources of exhibition at "Ming Zong Calligraphy Art Museum," which has become an important location of calligraphy exhibition and exchange in southern Taiwan. It is the concrete practice of life aesthetics to take roots and shorten the cultural gap between city and country.

Mr. Tsai Ming-tzann's calligraphy art follows the ancient tradition and make innovations. He integrates the aesthetics of the copybooks and stele inscriptions, writes a large number of poems, and shows the literati's performing content. At the same time, he learns from the avant-garde style of Japanese ink and the western abstract expressionism and reflects the visual style and abstract meaning in the contemporary art trend. Chungshan National Gallery of National Dr. Sun Yat-sen Memorial Hall, Ministry of Culture, holds "Classic & Trend—Tsai Ming-tzann Calligraphy Art Exhibition" this time. It is to pay tribute to his long cultivation and contribution to calligraphy education. We sincerely welcome the art lovers to pay a visit and appreciate the changes and new look of contemporary calligraphy aesthetics.

Minister of Culture, Lee Yung-te

館長序

　　蔡明讚先生別署適評，一九五六年生於臺灣桃園，就學省立臺北師專、中國文化大學中文系、國立臺灣師範大學國文研究所，師專時期開始臨碑摹帖，學習詩文、閱讀書論，其後教職餘暇參與「墨潮會」、「中華民國書法教育學會」，結合同道從事藝術創作探索，對於書法教育的推展不遺餘力。現為《書法教育月刊》社長，撰述文字三百餘篇、逾百萬言，為臺灣當代書法的發展錄實存真。

　　先生的書法藝術創作包容古典和現代，篆、隸、草、行、楷五體皆擅，風格入古出新，尤以金文最具特色，大量自作詩入書，彰顯文人內涵；現代書藝部分則以取資傳統、表現抽象、反映現代為旨歸，作品多造形化、視覺化、少字數化、禪意化，期以黑白色相、虛實辯證、陰陽易理，探索抽象筆墨的世界。

　　在書法教育領域耕耘數十年，蔡明讚先生期望書法不僅是藝術創作，也能融入當代常民生活。本館長期為國內書畫界提供多樣化的展覽空間，每年辦理新春揮毫活動，推廣書法文化的理念頗為契合，很高興邀請先生於中山國家畫廊舉辦個展，將這位書法教育導師的創作實踐與書藝成就，與社會大眾共同分享。

國立國父紀念館 館長

王蘭生

Preface by Director-general

Mr. Tsai Ming-tzann, also called Shi-ping, was born in Taoyuan, Taiwan, in 1956. He studied in Provincial Taipei Teachers' College, Department of Chinese Literature, Chinese Culture University, and Graduate Institute of Chinese, National Taiwan Normal University. In Taipei Teachers' College, he started to imitate stele inscriptions, learn poetry, and read theories of calligraphy. Afterwards, when working as a teacher, he spent his leisure time participating in "Mo Chao Hui" and "The Republic of Chinese Society for Calligraphy Education," engaging in art creation and exploration with those with the same interest and sparing no effort to promote calligraphy education. At present, he is the president of Calligraphy Education Journal, for which he has written more than 300 articles and over million characters and recorded the development of contemporary calligraphy in Taiwan.

Mr. Tsai's calligraphy art includes the classical and modern styles and excels in all the five scripts, seal script, clerical script, cursive script, running script, and regular script. Creating the new spirit from the ancient style, he specializes in the bronze script. A large number of self-made poems are included in his publications, highlighting his literary nature. His modern calligraphy art based on tradition aims to express abstract and reflect modernity. Made with less number of characters, the works of various forms are visualized and endowed with the Zen style. It is expected to explore the abstract ink world through the black and white colors, dialogues between the concrete and the abstract, and patterns of Yin and Yang.

Cultivating the field of calligraphy education for decades, Mr. Tsai has the expectation that calligraphy is not only regarded as art creation but also integrated into modern people's daily life. Sharing the similar spirit of promoting calligraphy cutlure, our hall has provided the diverse exhibition space for the domestic calligraphy and painting circle for long and holds the spring couplet writing activity on Chinese New Year every year. We are glad to invite Mr. Tsai to hold the exhibition at Chungshan National Gallery and share the creative practice and calligraphy achievement of the calligraphy educator with the social public.

Director-general of National Dr. Sun Yat-sen Memorial Hall

Lance Wang

目録

4　部長序 ◎李永得

6　館長序 ◎王蘭生

11　典則潮風 270×70cm 2021

12　意經典在新風 122×60cm×2 2021

15　金文造形 137×34.5cm×8 2020

18　思無象 115×53cm 2021

21　篆草造形系列 70×70cm×4 2021

22　靜參 53×144cm 2021

25　現代書藝 金文之變奏 137×34.5cm×4 2020

28　現代書藝 - 書象龍 135×34cm×6 2020

31　書象系列 90×90cm 2021

33　篆草造形系列 70×70cm×4 2021

35　書象系列 70×135cm×5 2021

36　融書 - 觀象 80×80cm 2021

37　融書 - 無礙 80×80cm 2021

40　現代書藝 破體之變奏 135×34cm×4 2020

45　篆草造形 83×79cm×3 2020

49　書象系列 90×90cm×8 2021

51　現代書藝 - 齋系列 90×90cm 2021

53　現代書藝 - 齋系列 90×90cm×8 2021

57　現代書藝 - 潮 240×480cm 2021

59　現代書藝 - 虛實之間 83×75cm×9 2021

61　現代書藝 - 趣 240×480cm2021

65　現代書藝 - 融書系列 80×80cm×8 2021

68　現代書藝 - 意寫山水 83×75cm×9 2021

71　現代書藝 - 真明系列 180×90cm×4 2021

74　墨潮迭起‧適評一生── 蔡明讚先生的書藝歷程◎黃智陽

84　簡歷

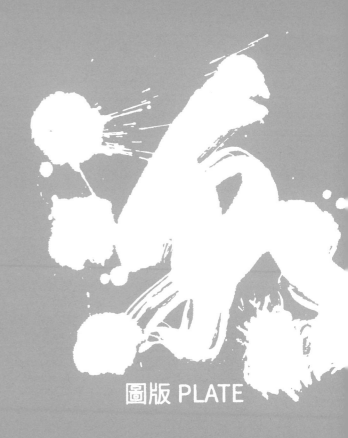

圖版 PLATE

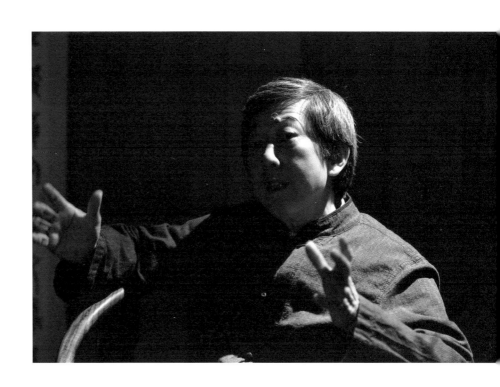

從書象裡面可看到陰陽、看到易經

你的藝術一定要有思想

不要小看黑白

如下圍棋般可無窮無盡

書法亦是

黑白的變化、互相之間的衝突

所產生的張力

絕對不是憑空冒出

必然是一個過程

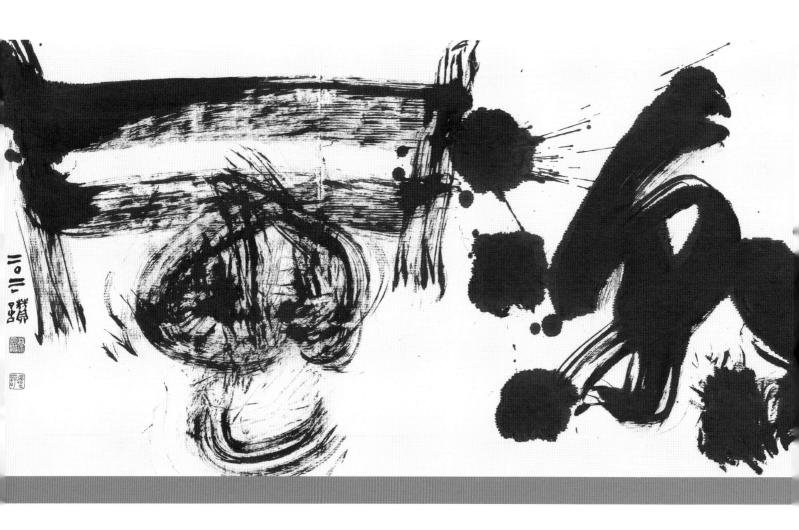

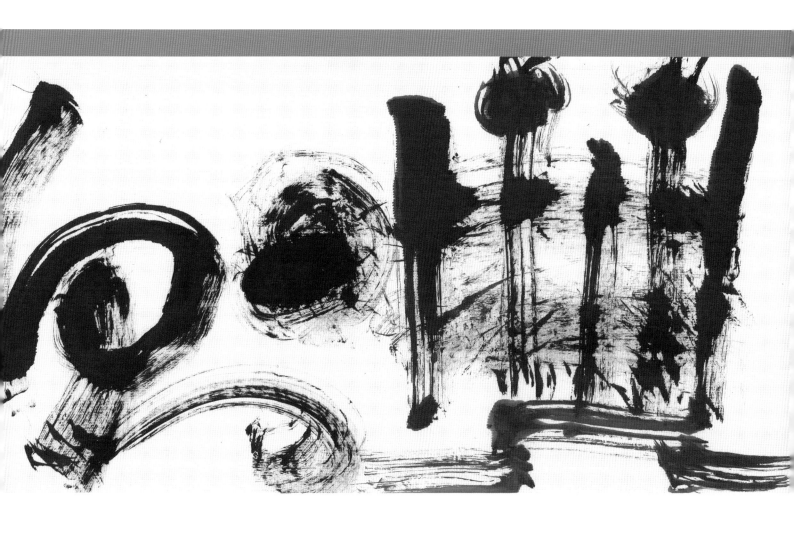

典則潮風 270×70cm 2021

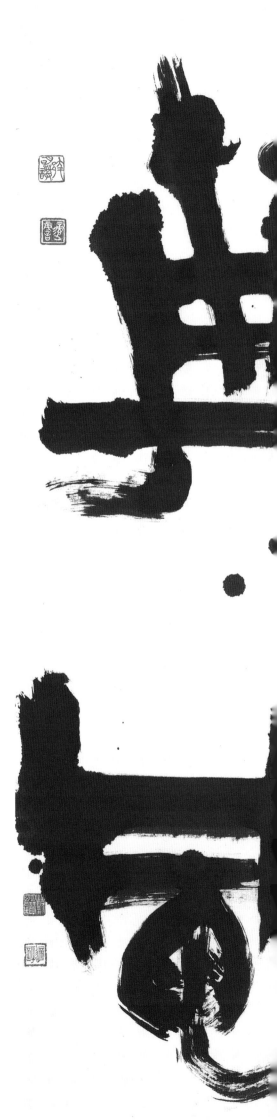

意經典在新風 122×60cm×2 2021

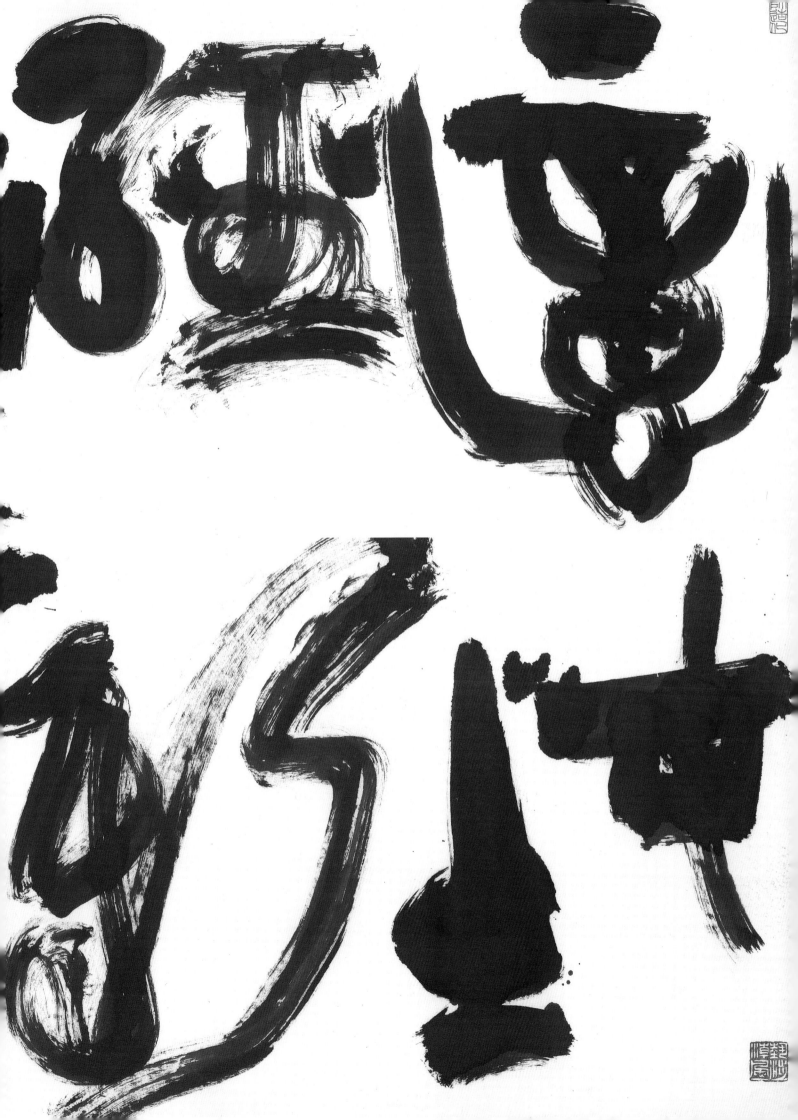

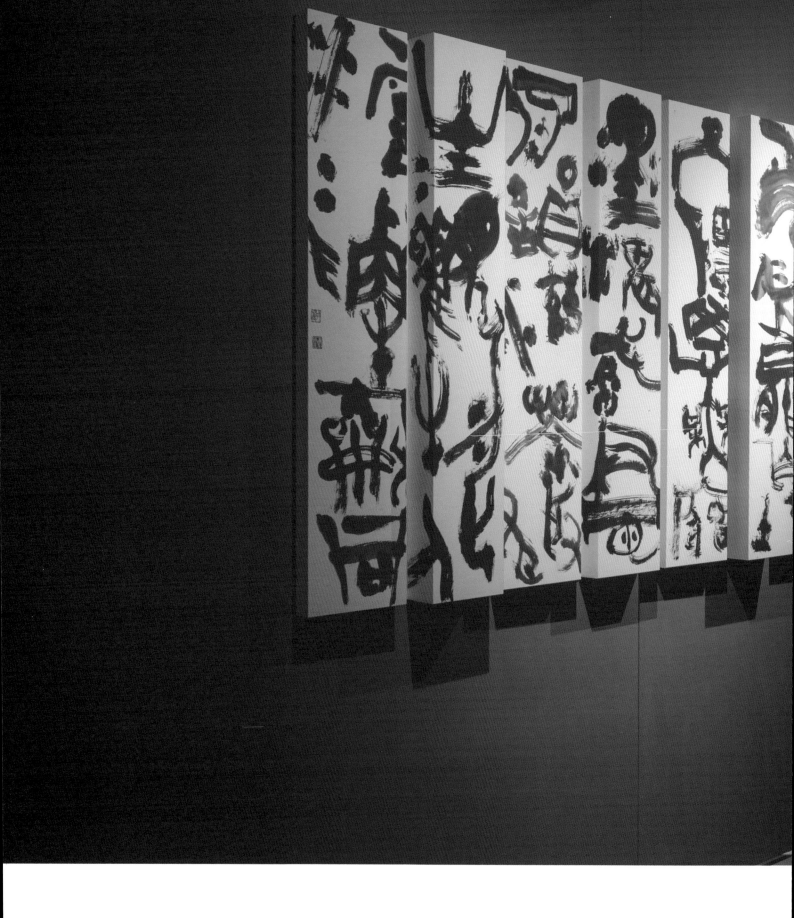

金文造形 137×34.5cm×8 2020

現代性的金文
自碑帖而來又不受拘束
生長出自我的面貌
在表現「墨趣」的前提下
對虛實與空間的問辯
東方文人意趣的畫面內
蘊含書寫當下對文字的想像

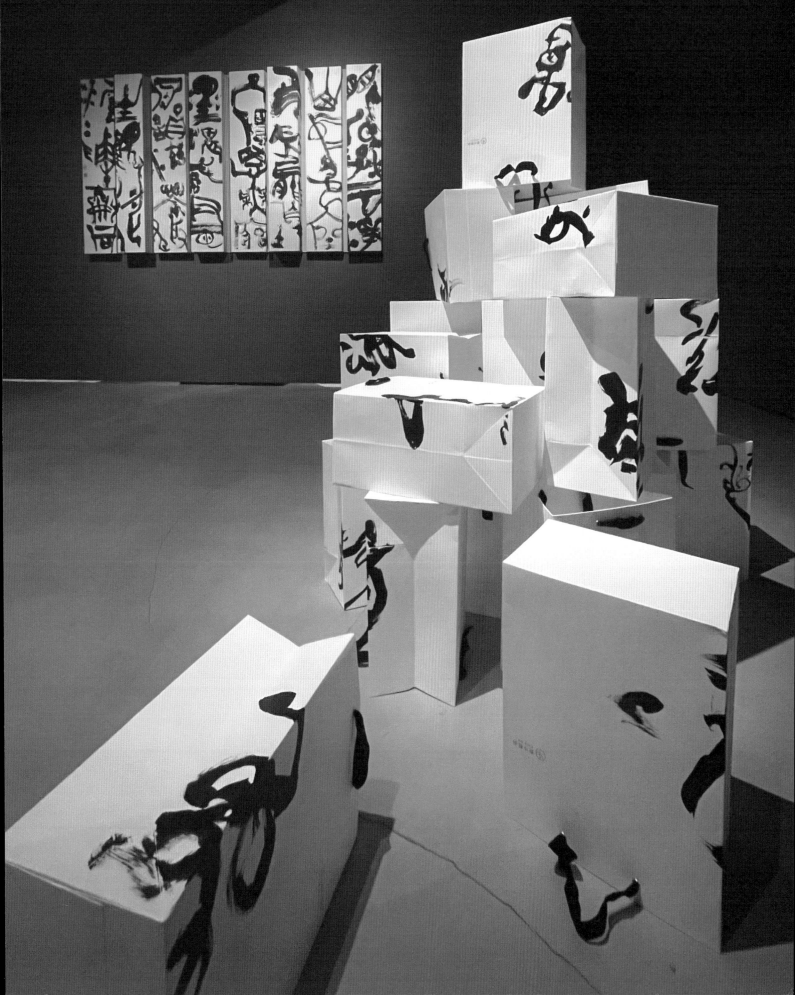

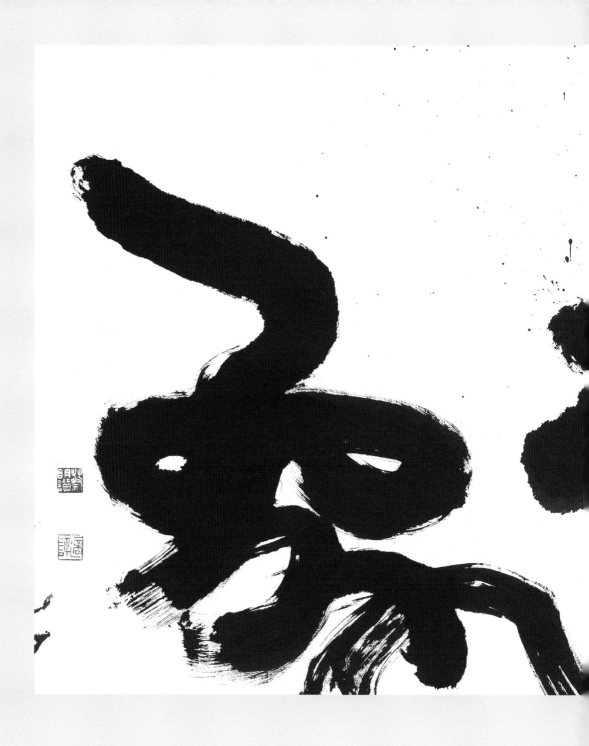

思無象 115×53cm 2021

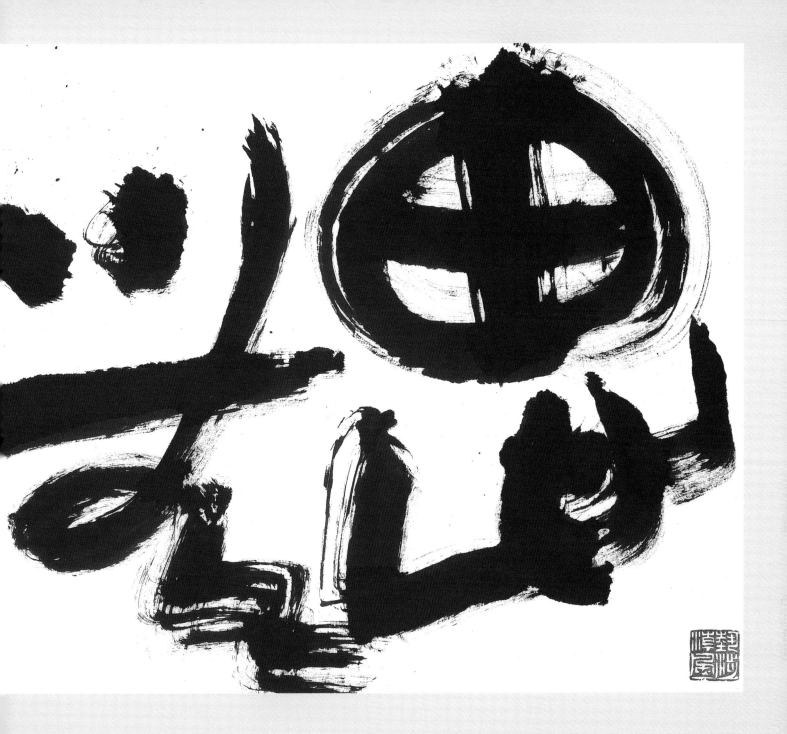

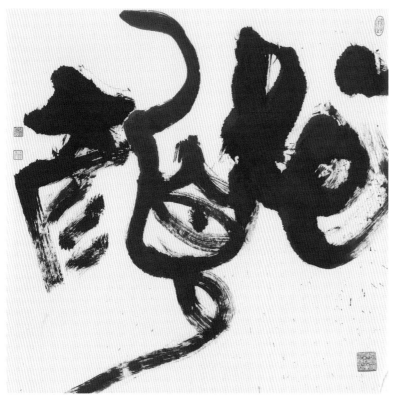
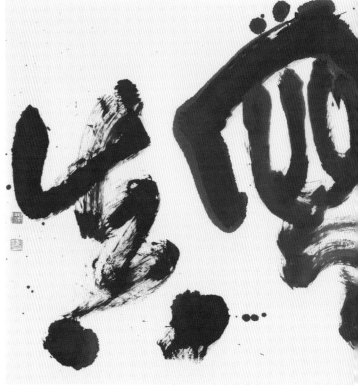

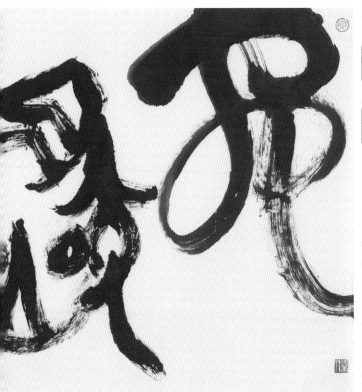 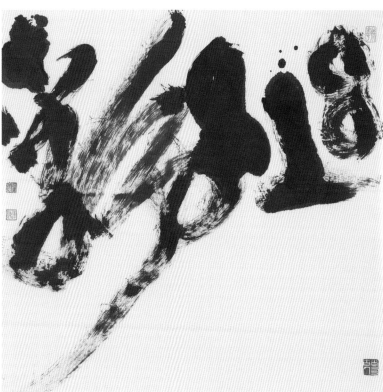

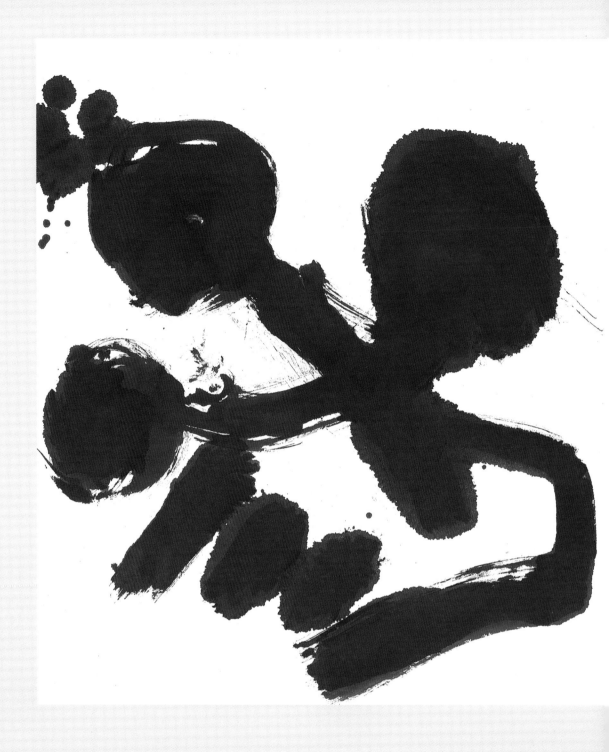

靜參 53×144cm 2021

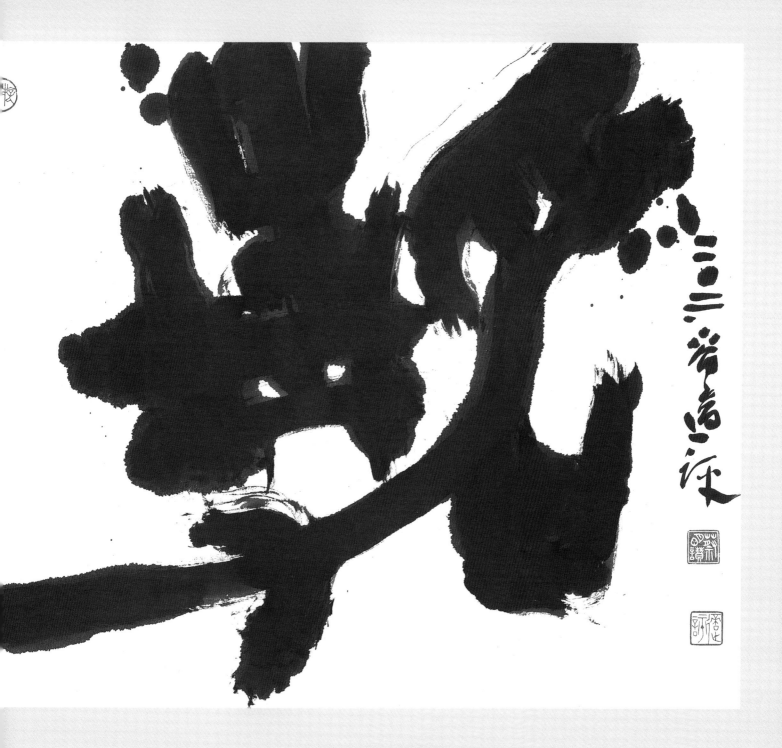

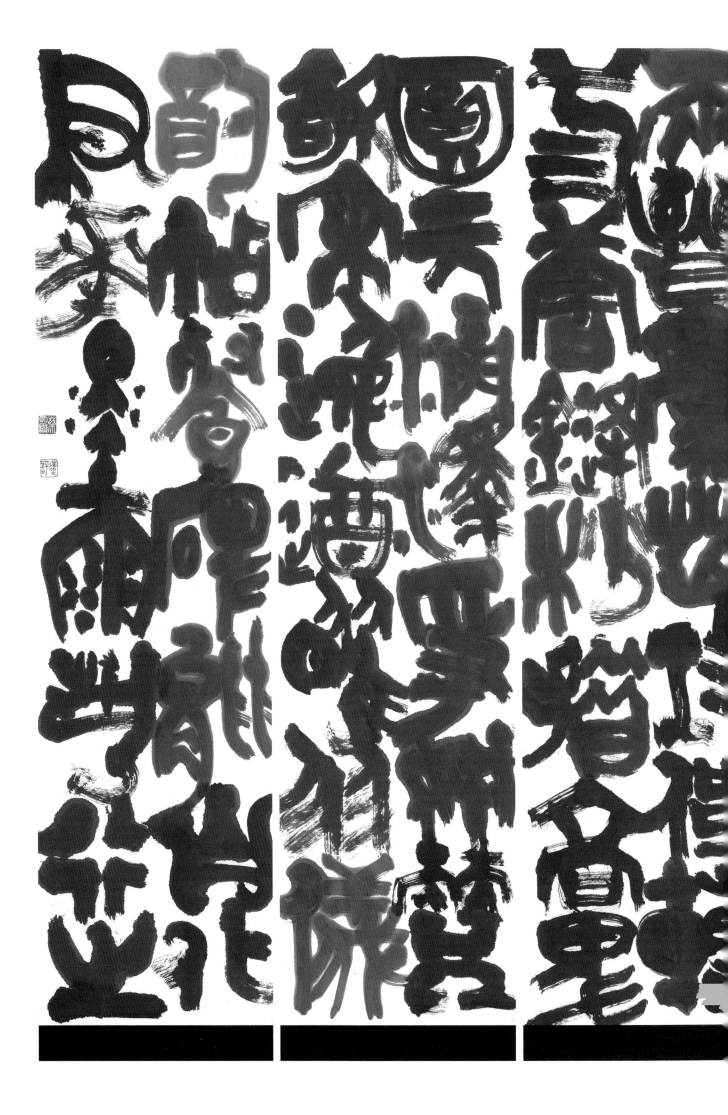

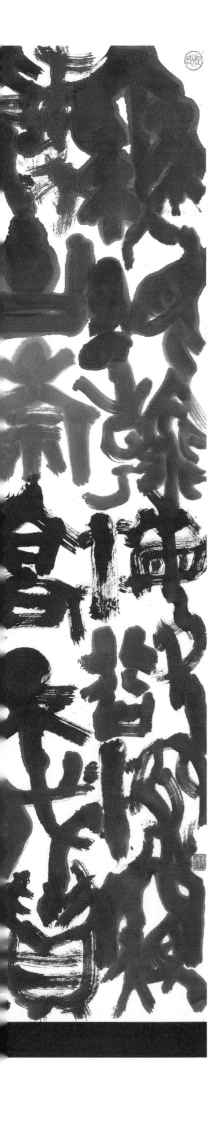

現代書藝 金文之變奏 137×34.5cm×4 2020

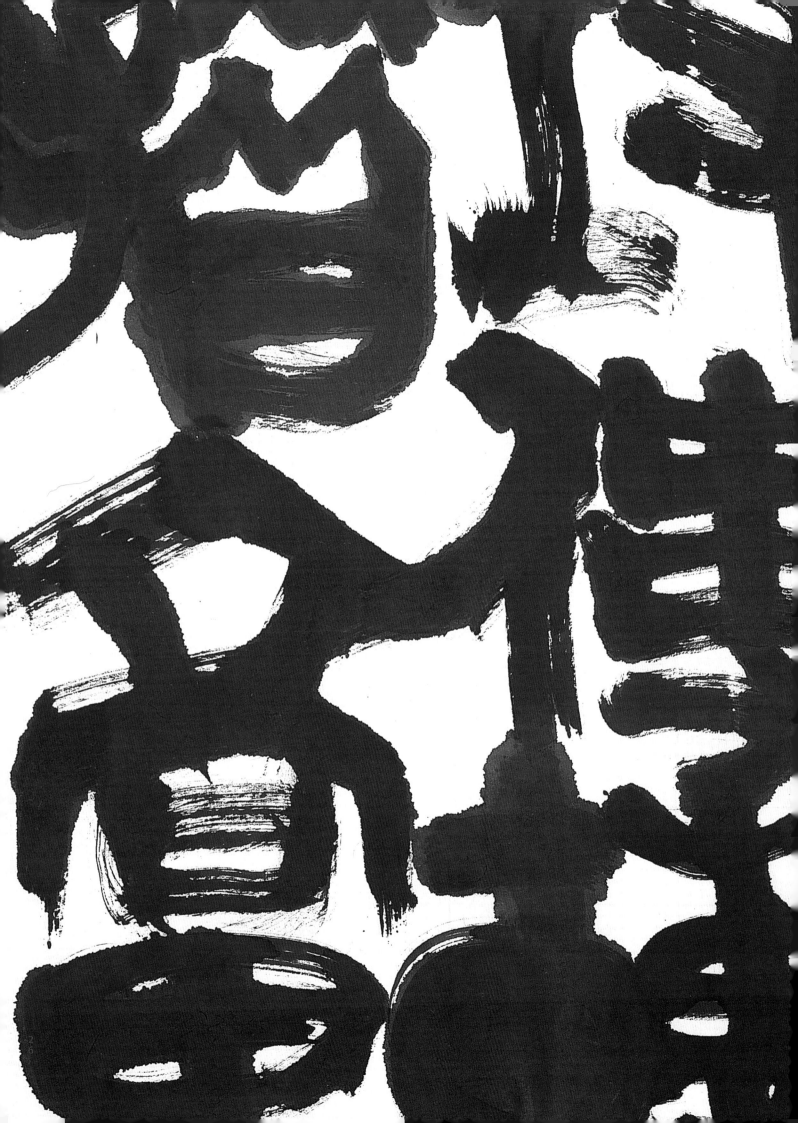

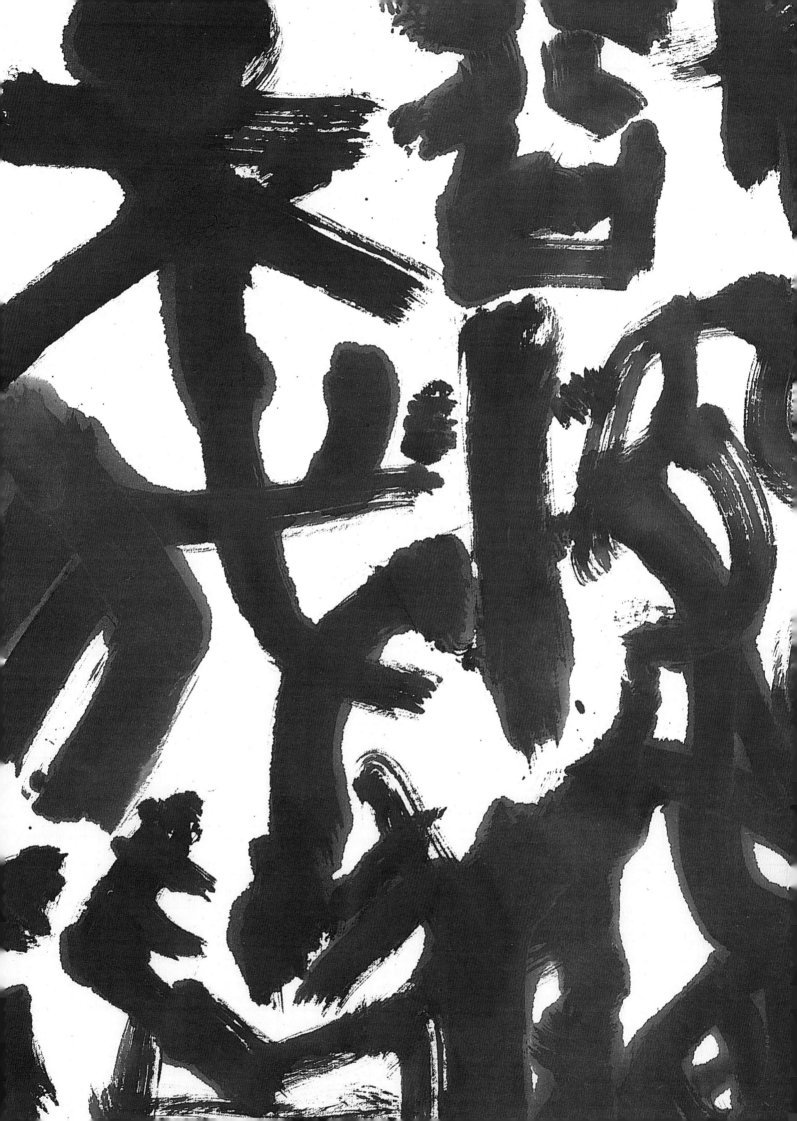

現代書藝 - 書象龍 135×34cm×6　2020

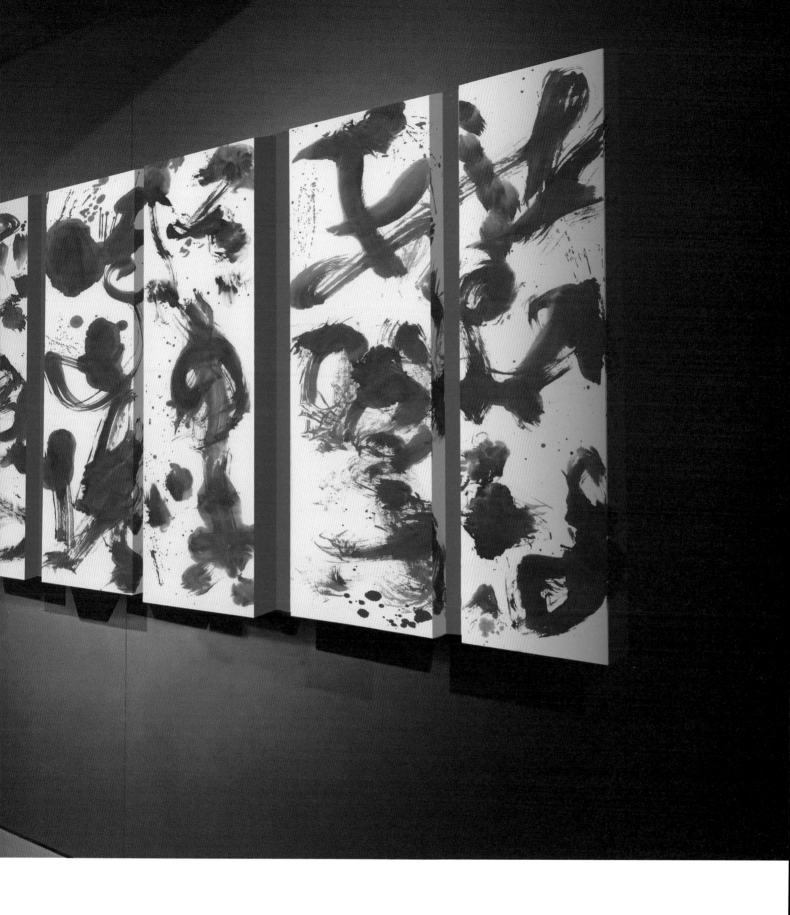

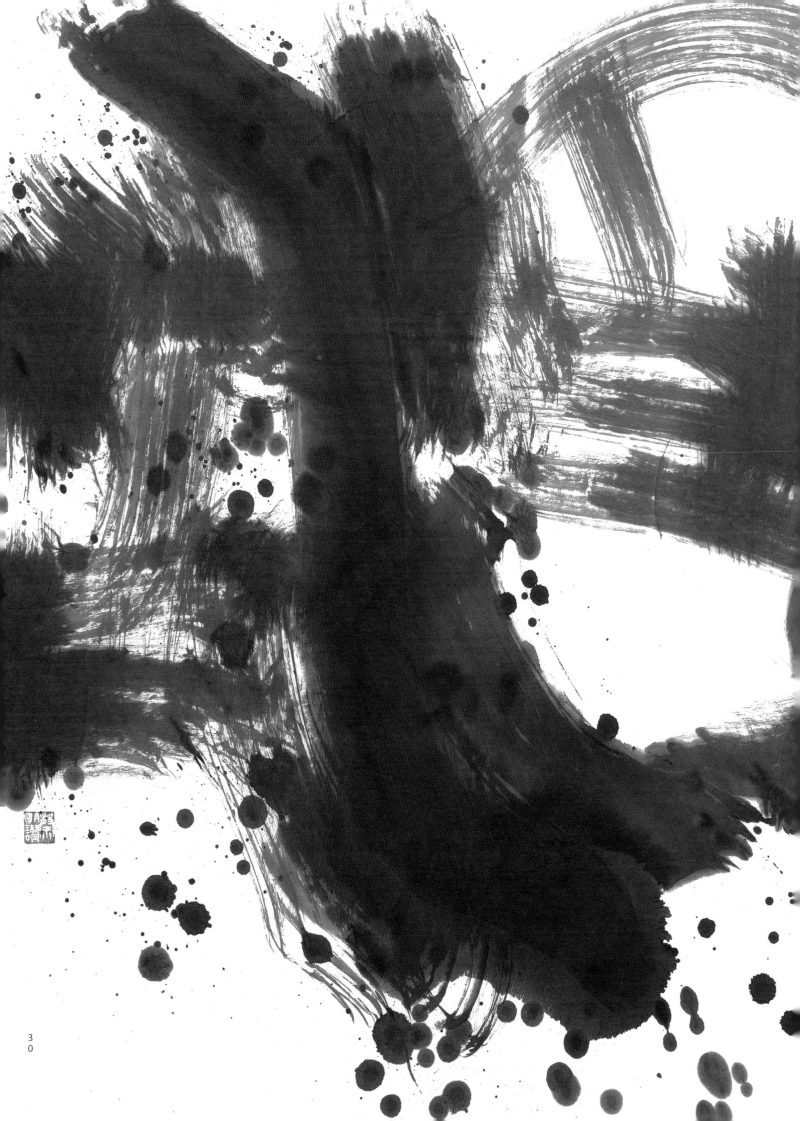

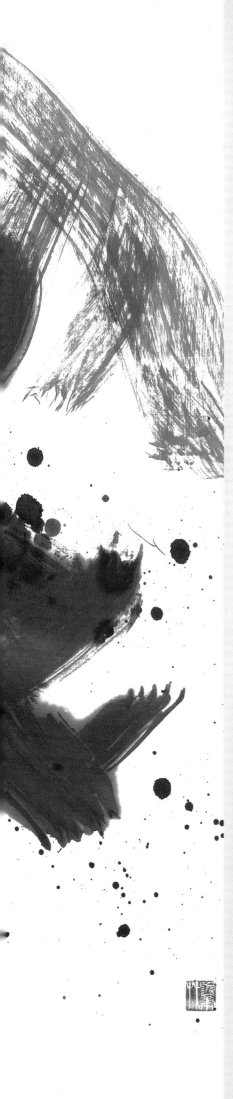

書象系列 90×90cm 2021

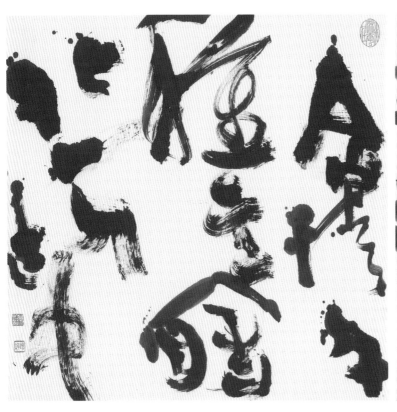
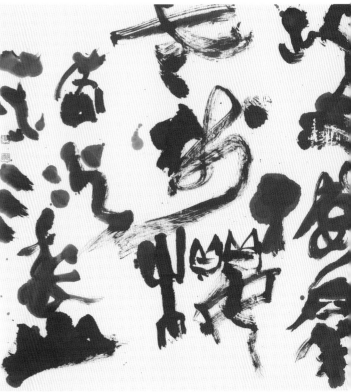

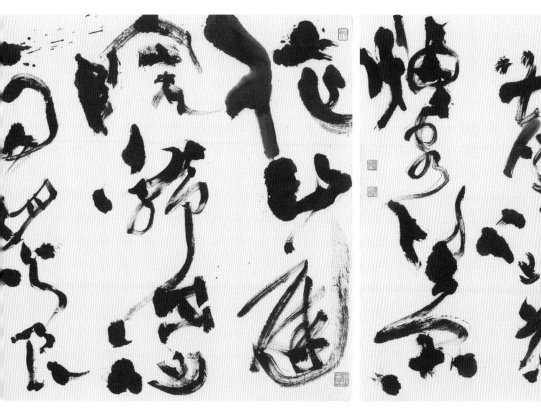
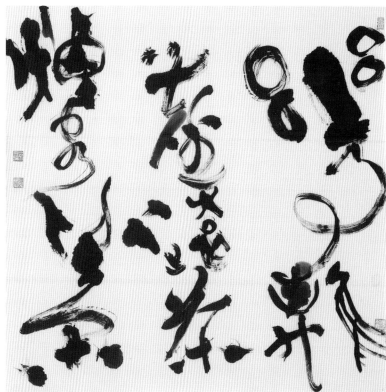

篆草造形系列 70×70cm×4 2021

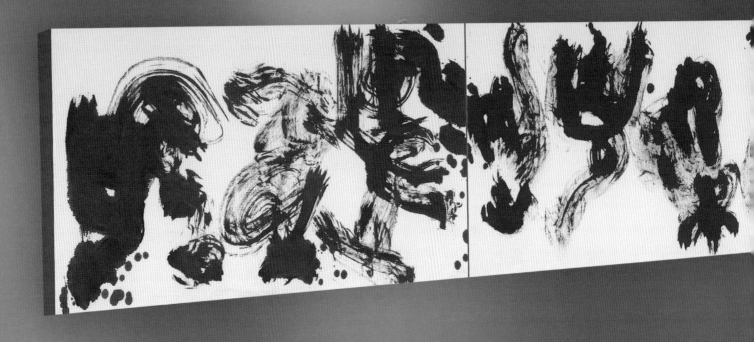

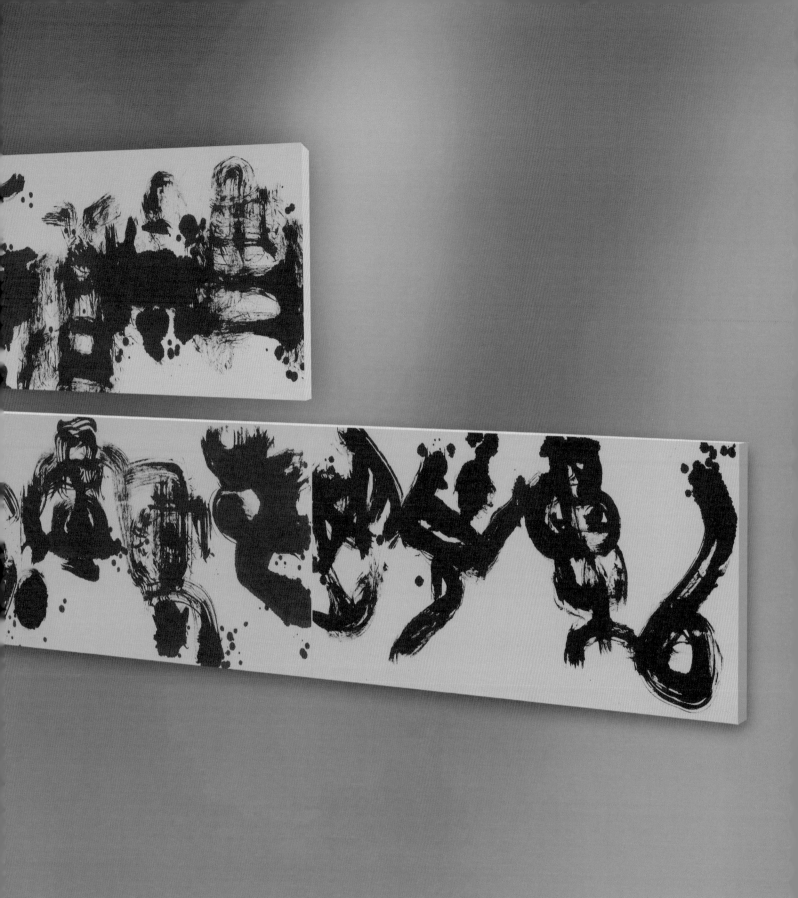

書象系列 70×135cm×5 2021

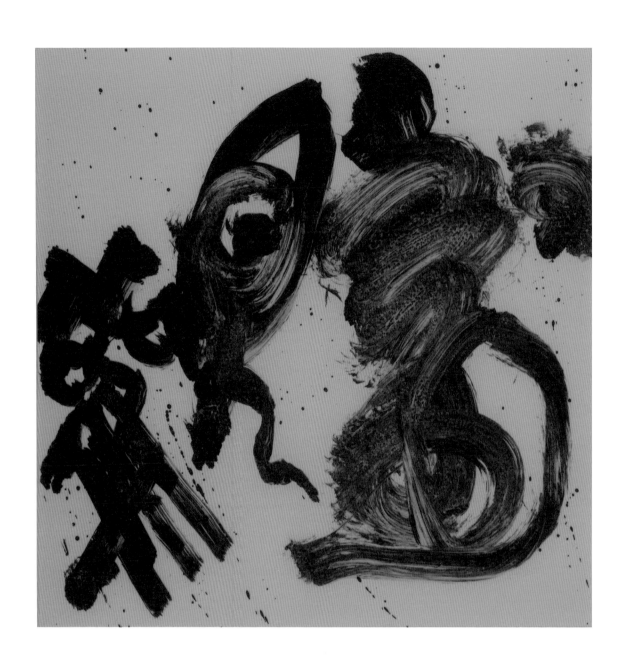

融書 - 觀象 80×80cm 2021

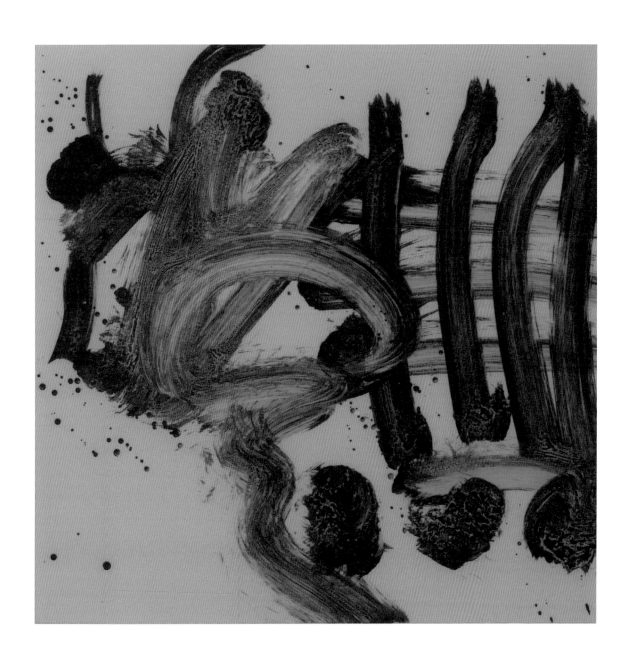

融書 - 無礙 80×80cm 2021

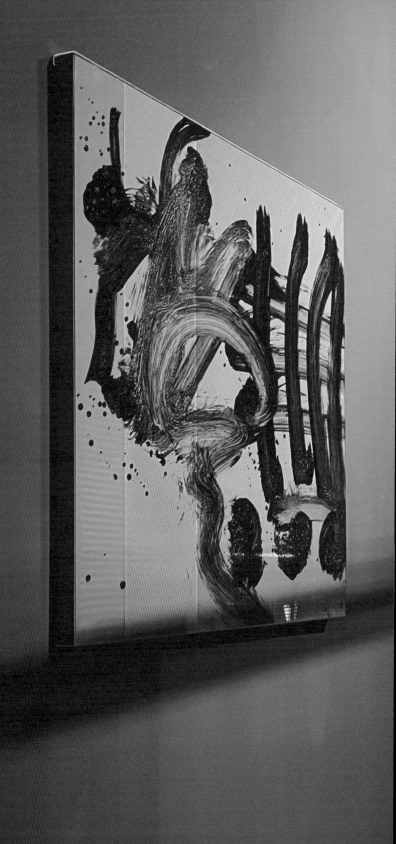

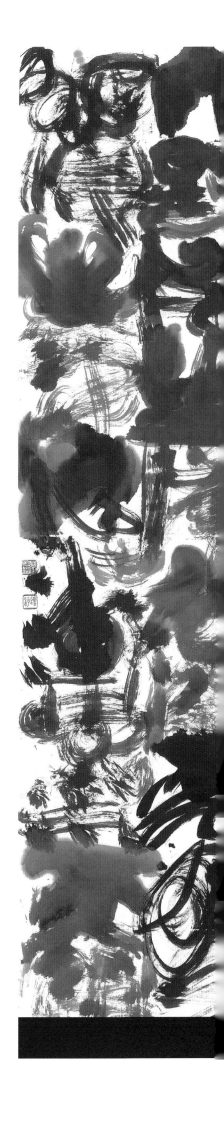

現代書藝 破體之變奏 135×34cm×4 2020

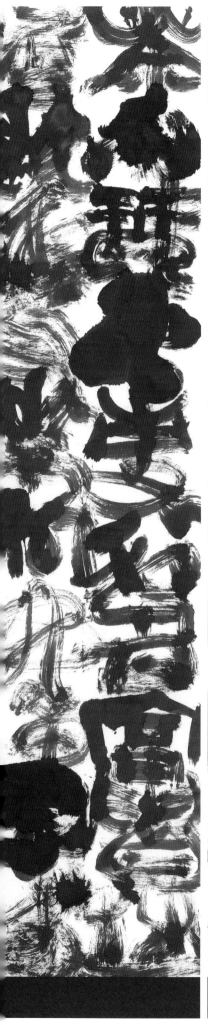
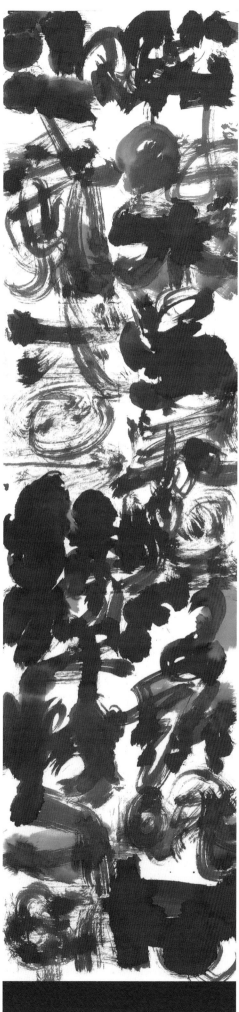
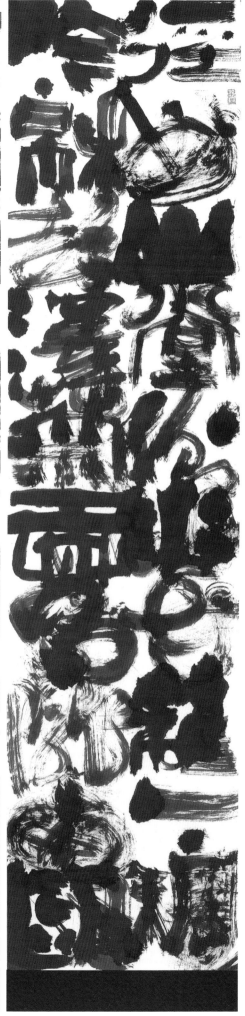

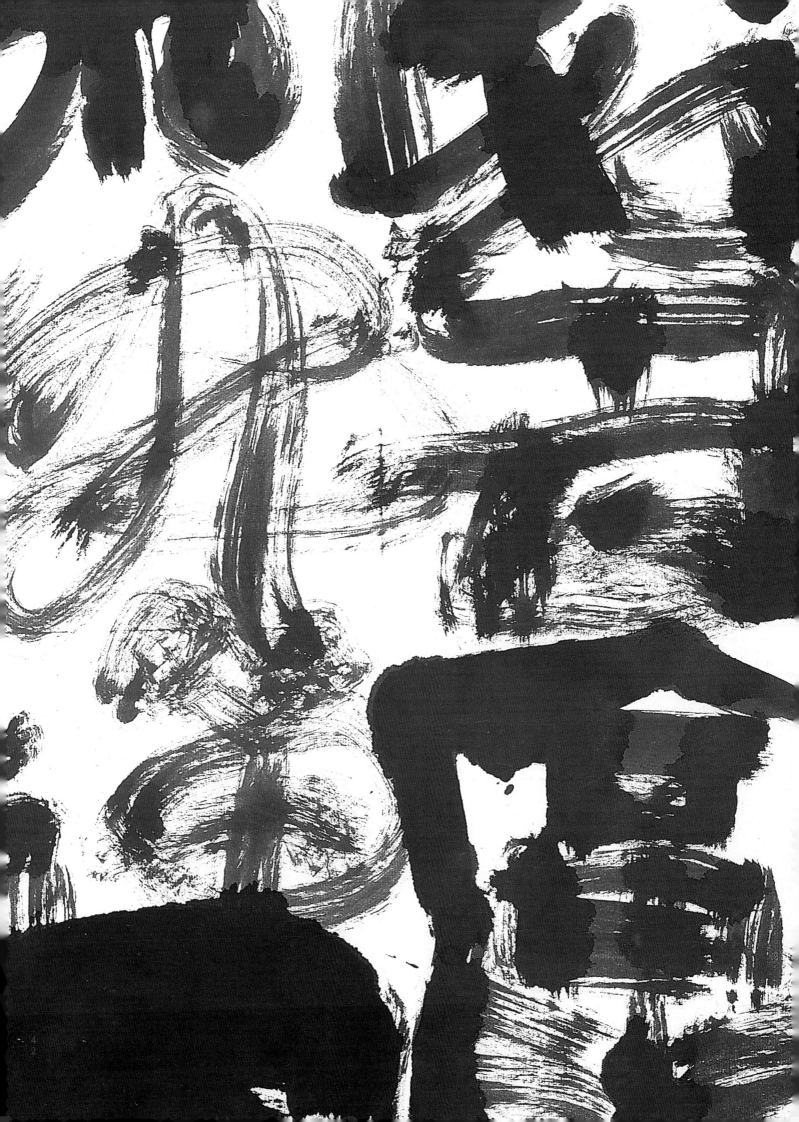

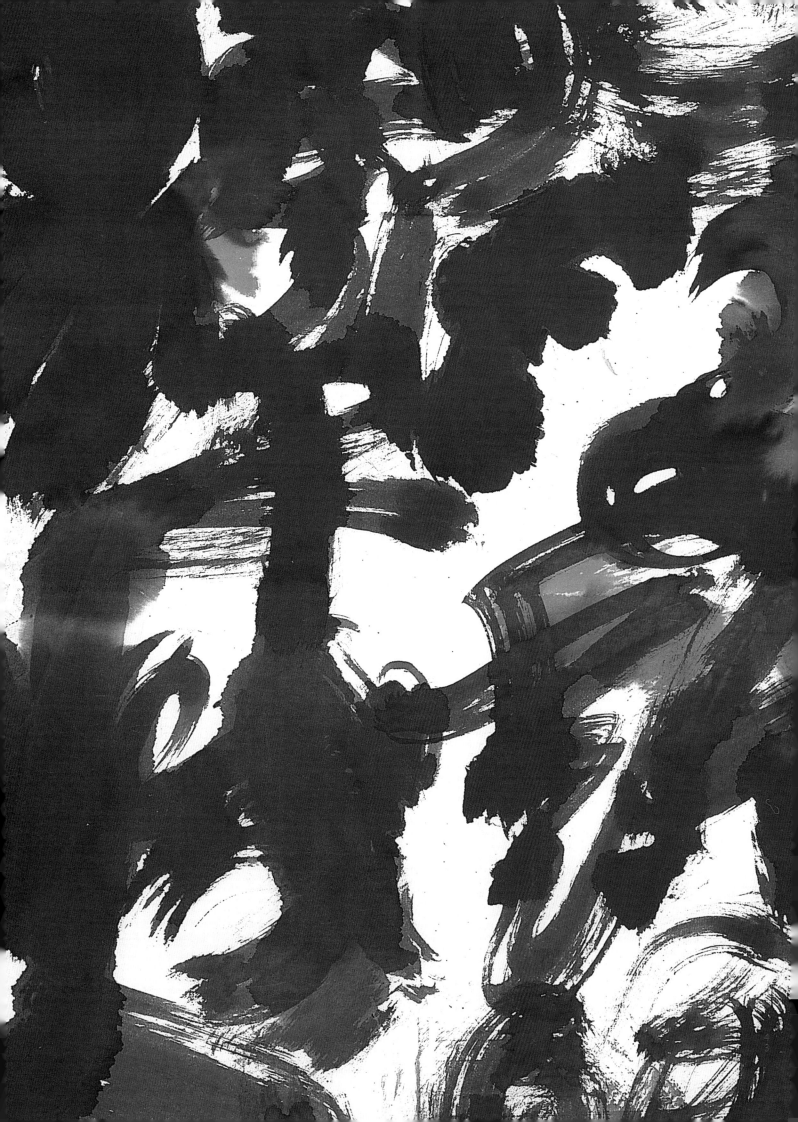

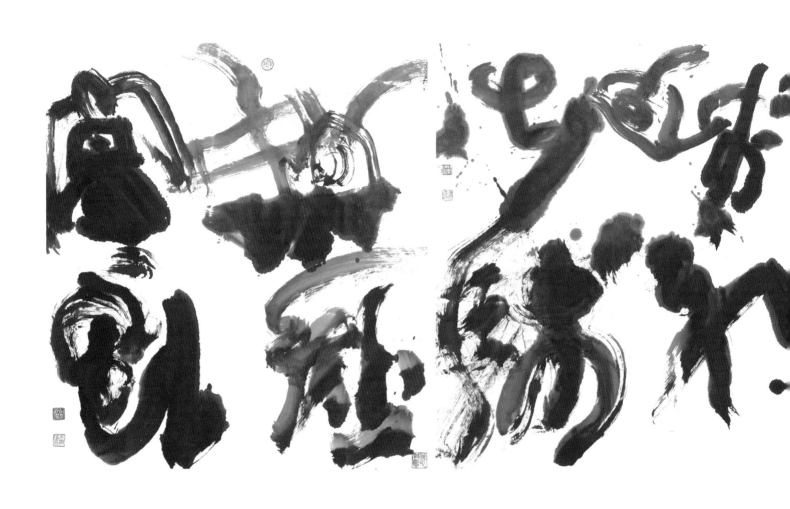

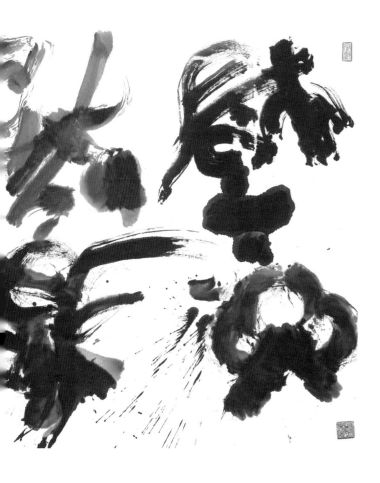

篆草造形 83×79cm×3 2020

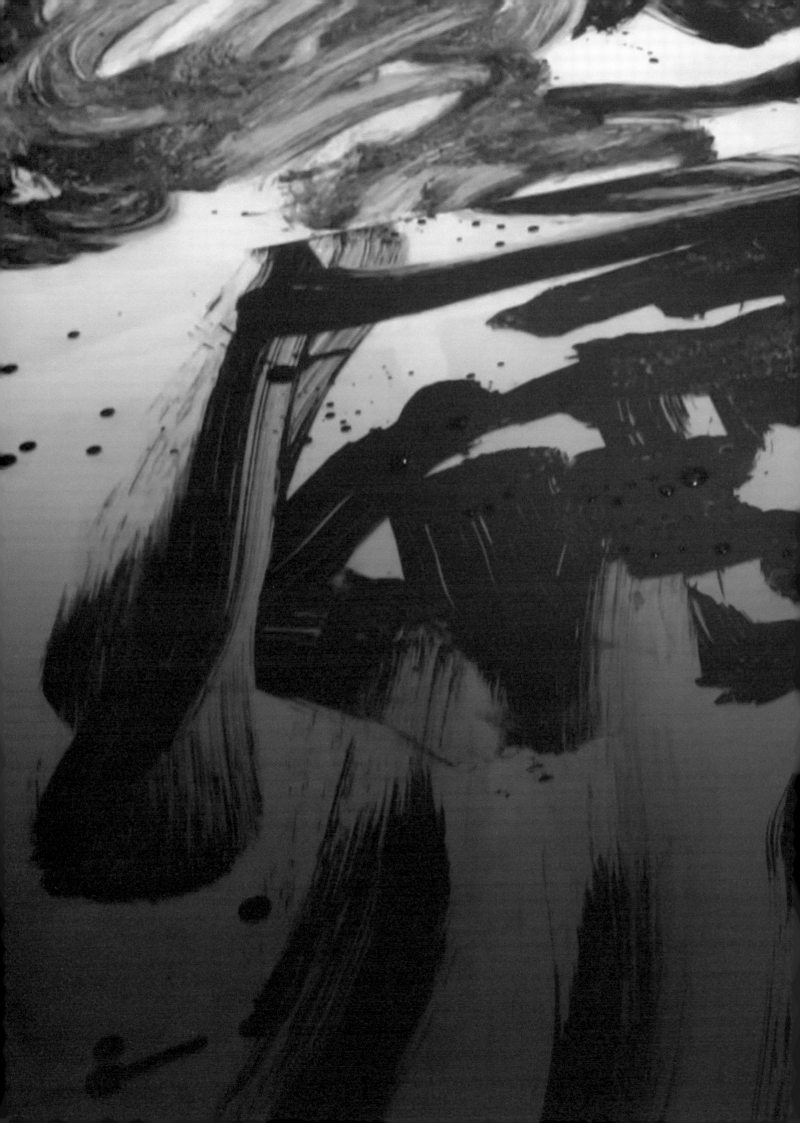

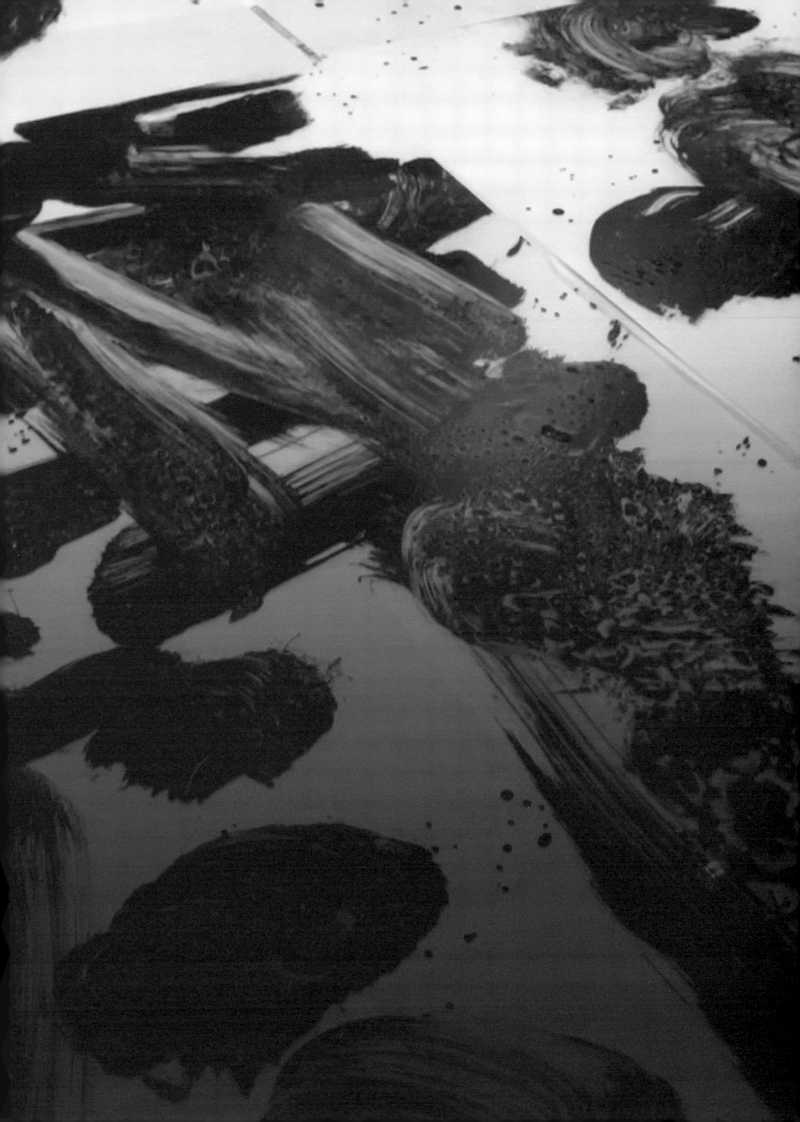

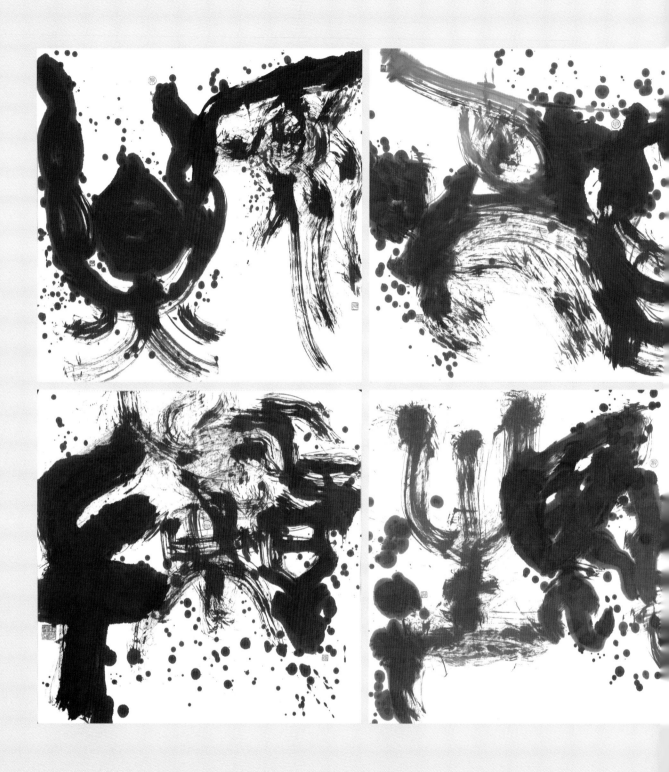

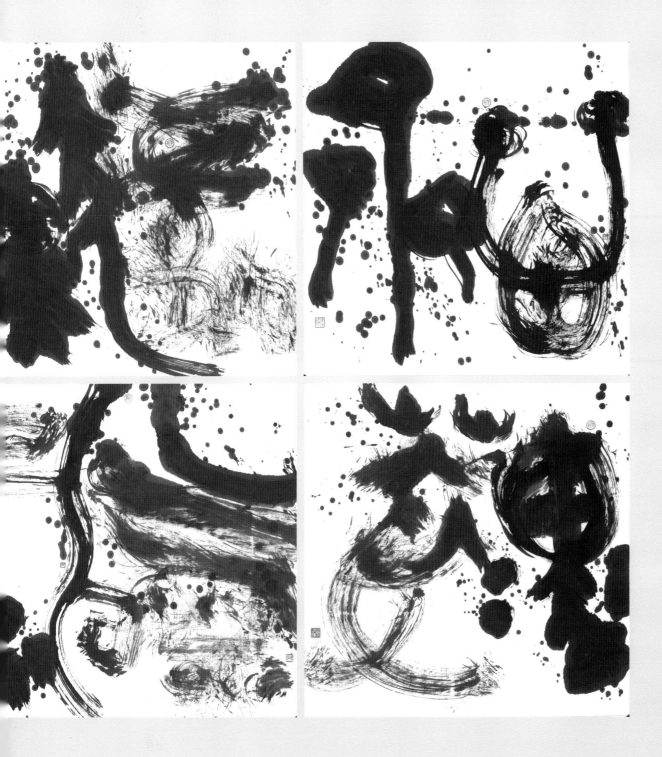

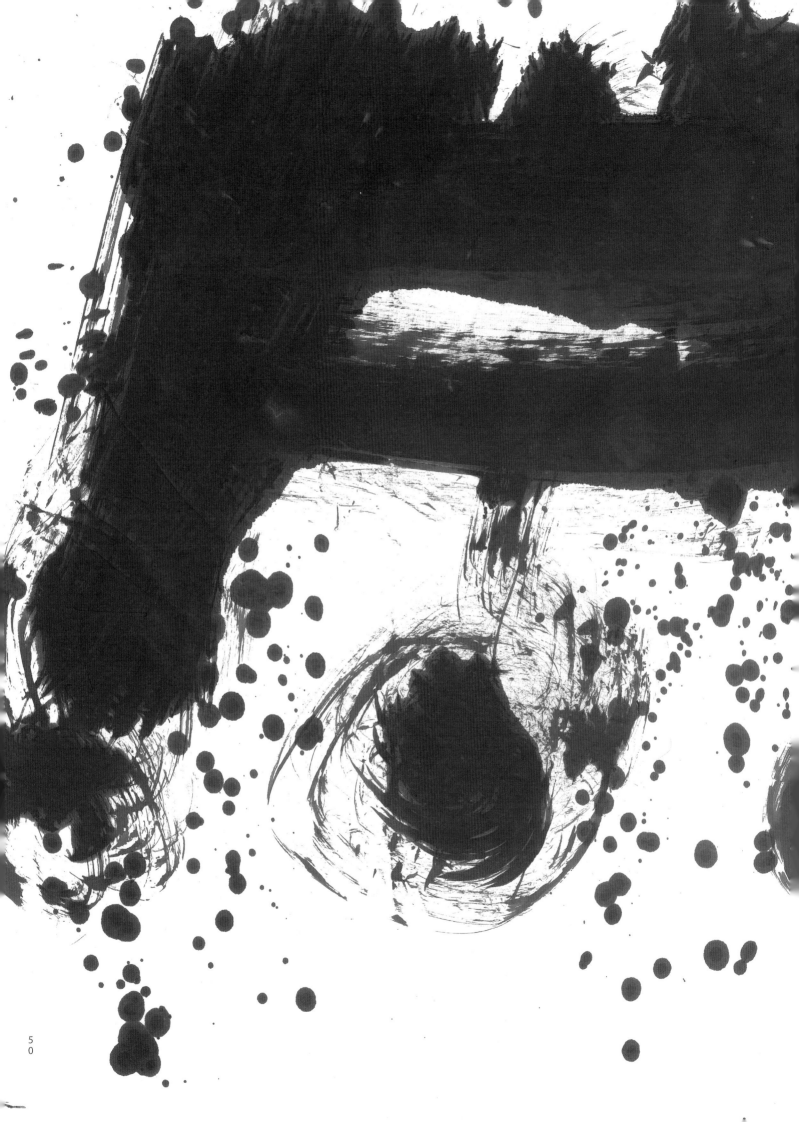

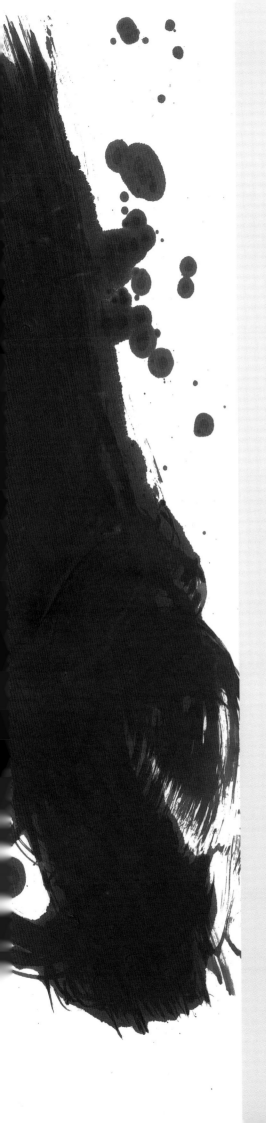

現代書藝 - 齋系列 90×90cm 2021

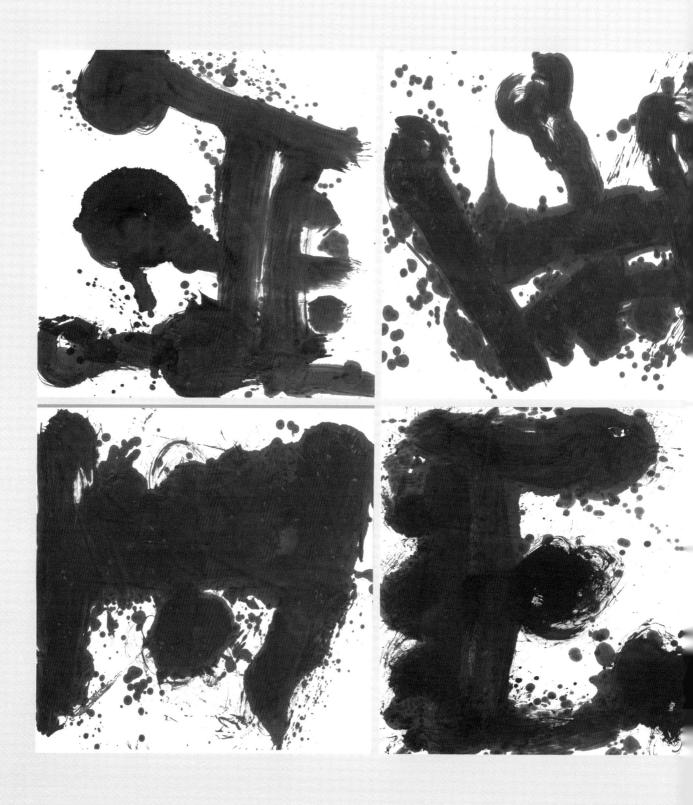

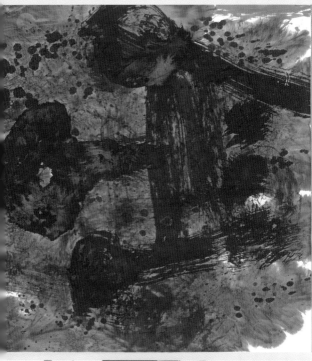
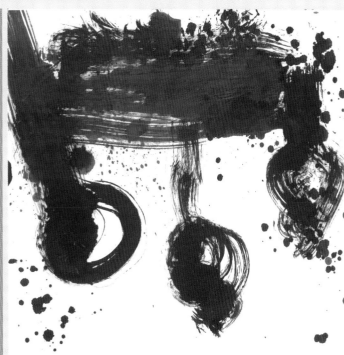
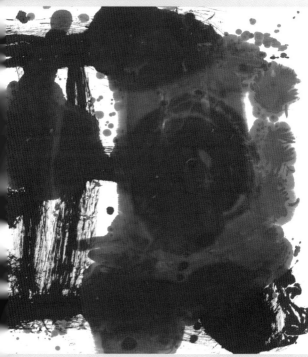
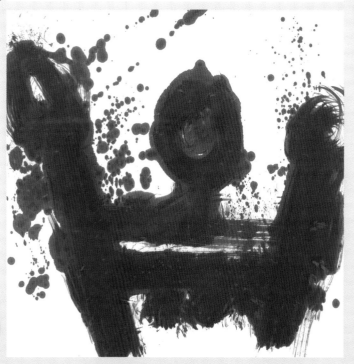

現代書藝 - 齋系列 90×90cm×8 2021

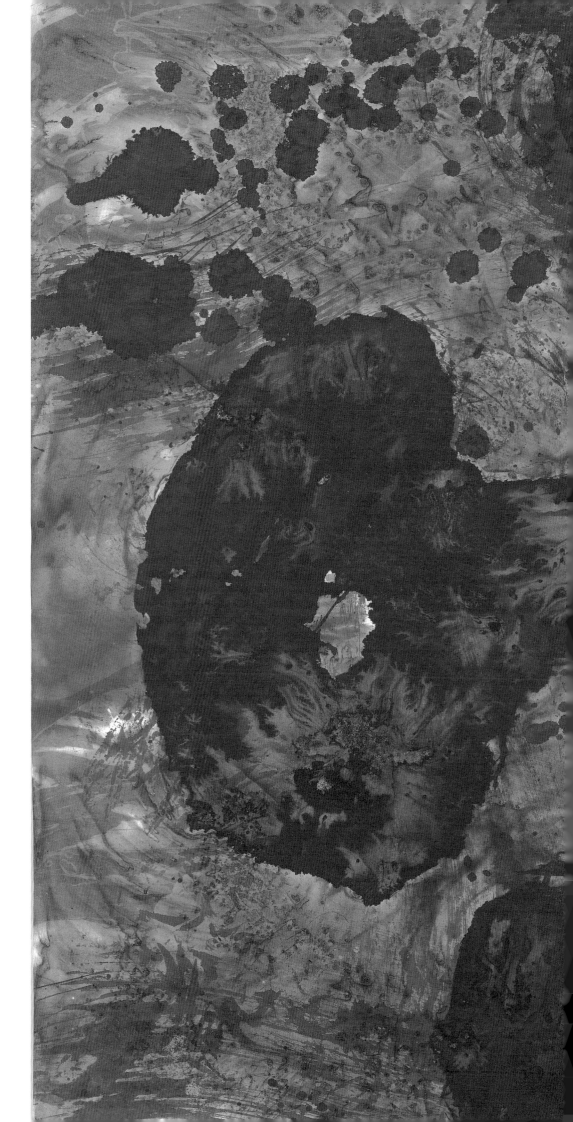

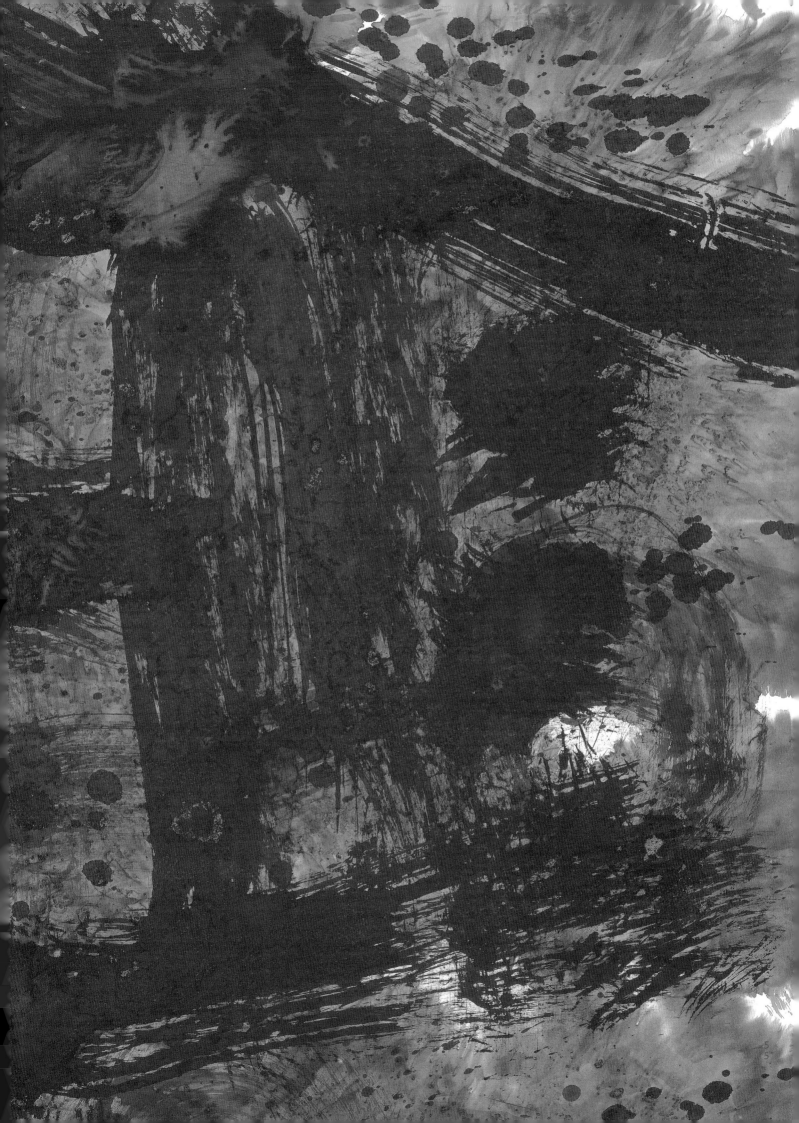

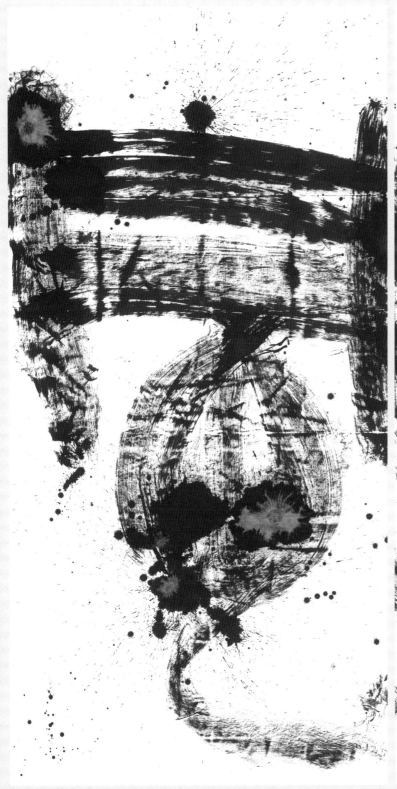
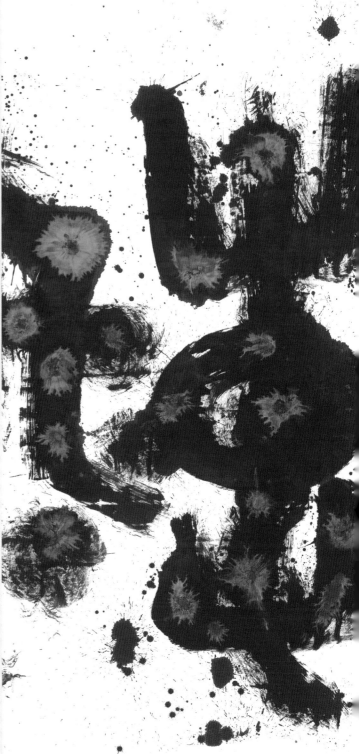

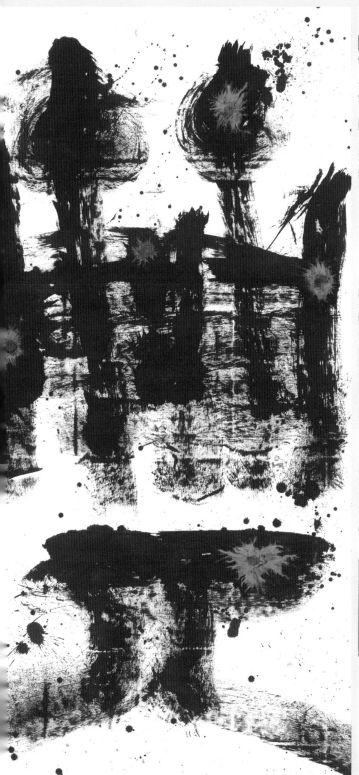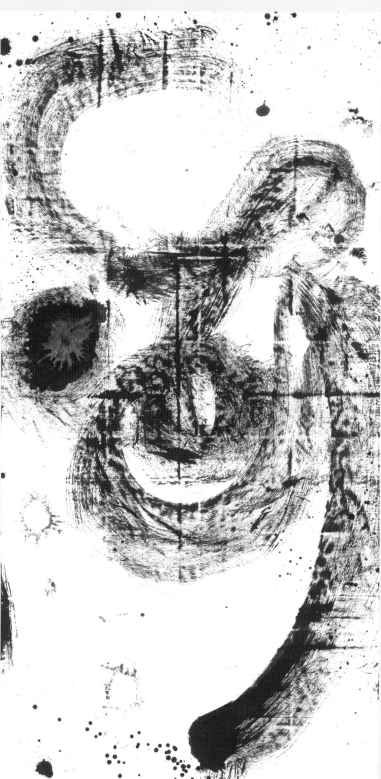

現代書藝 - 潮 240×480cm 2021

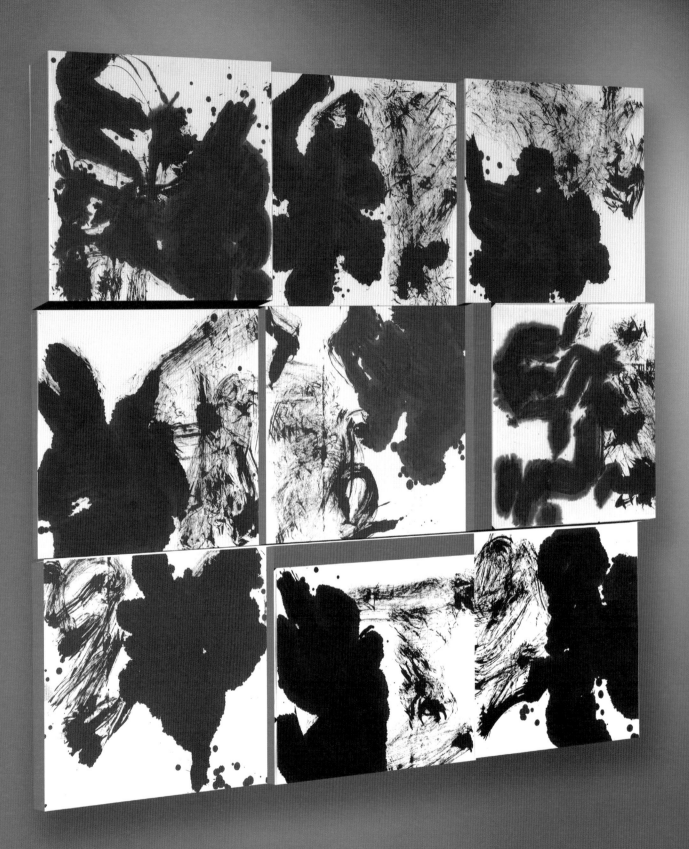

現代書藝 - 虛實之間 83×75cm×9 2021

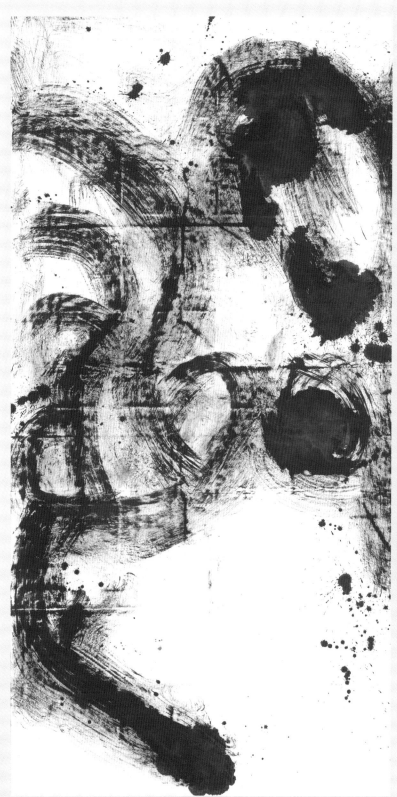
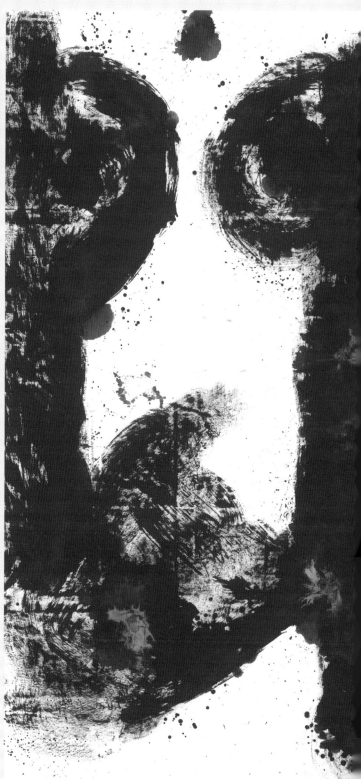

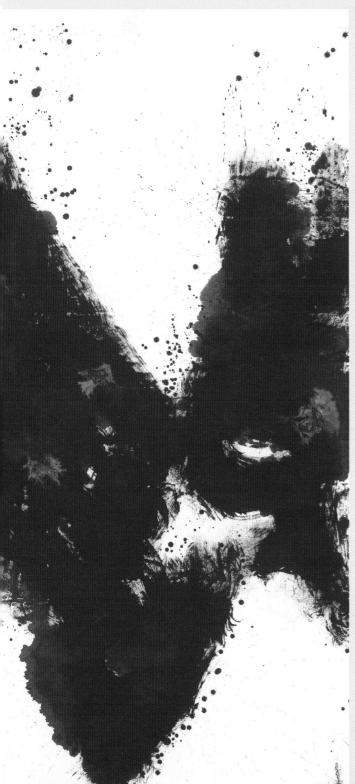
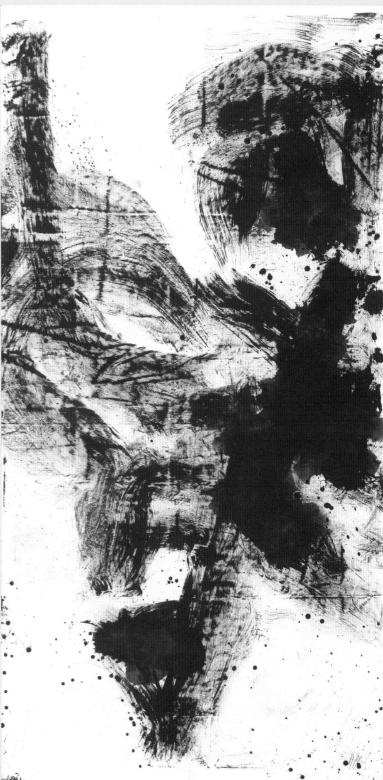

現代書藝 - 趣 240×480cm2021

我所認識的蔡明讚老師
「一生只為書法忙」
樂在其中

———————— 楊旭堂

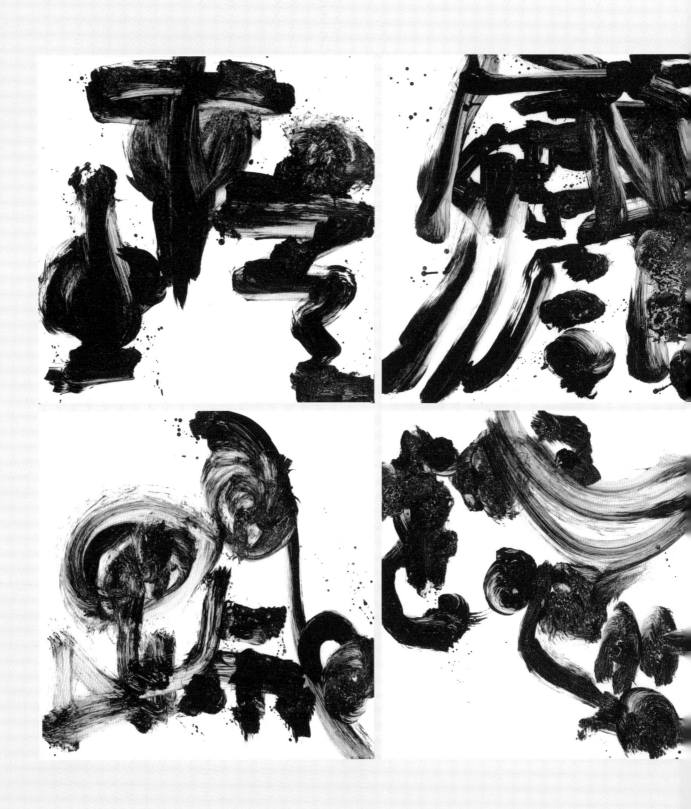

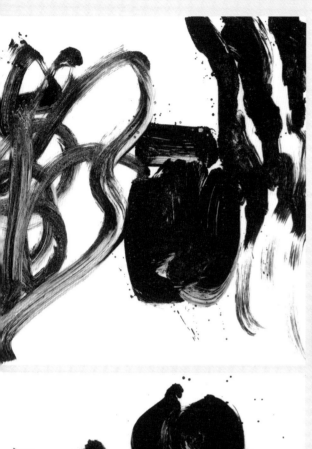
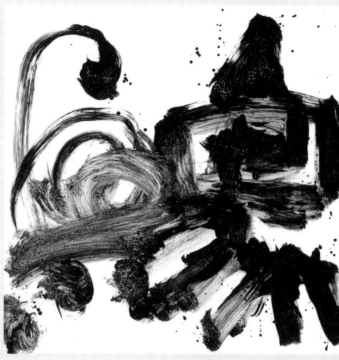
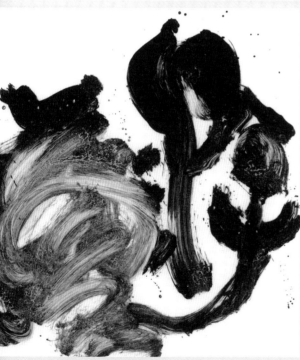
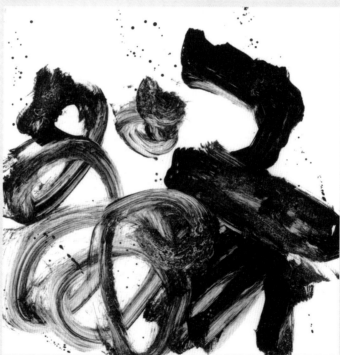

現代書藝 - 融書系列 80×80cm×8 2021

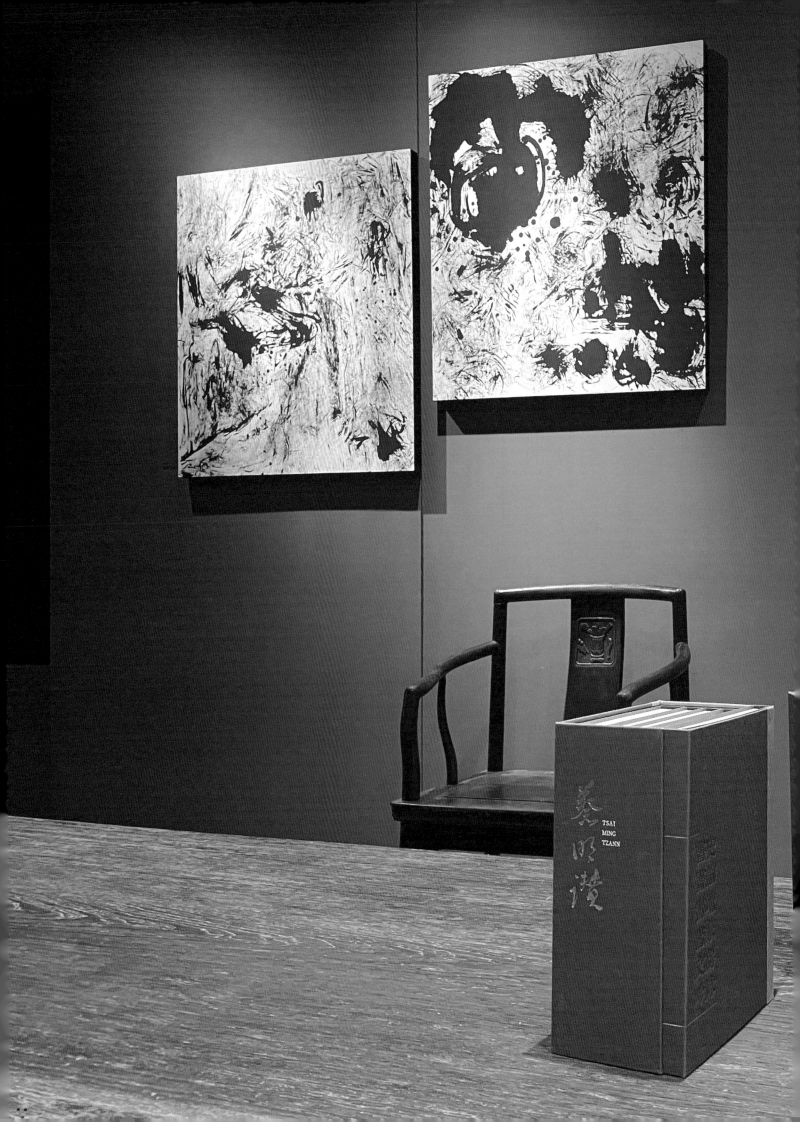

蔡明瓚
TSAI
MING
TZANN

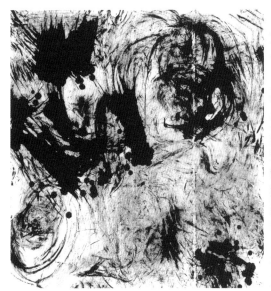
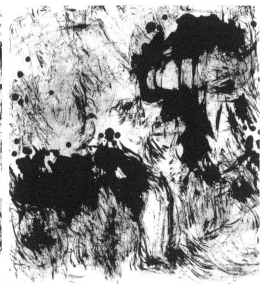
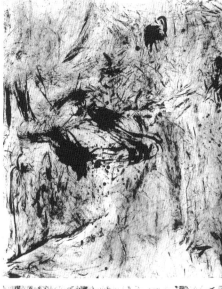
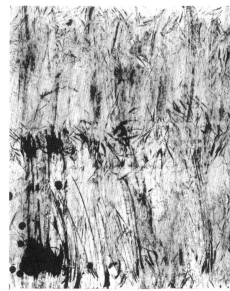

現代書藝 - 意寫山水 83×75cm×9 2021

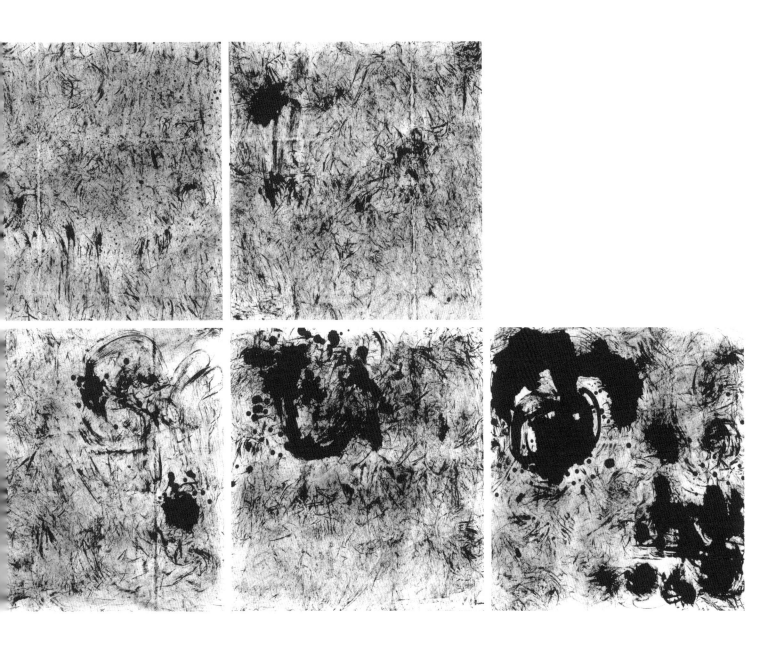

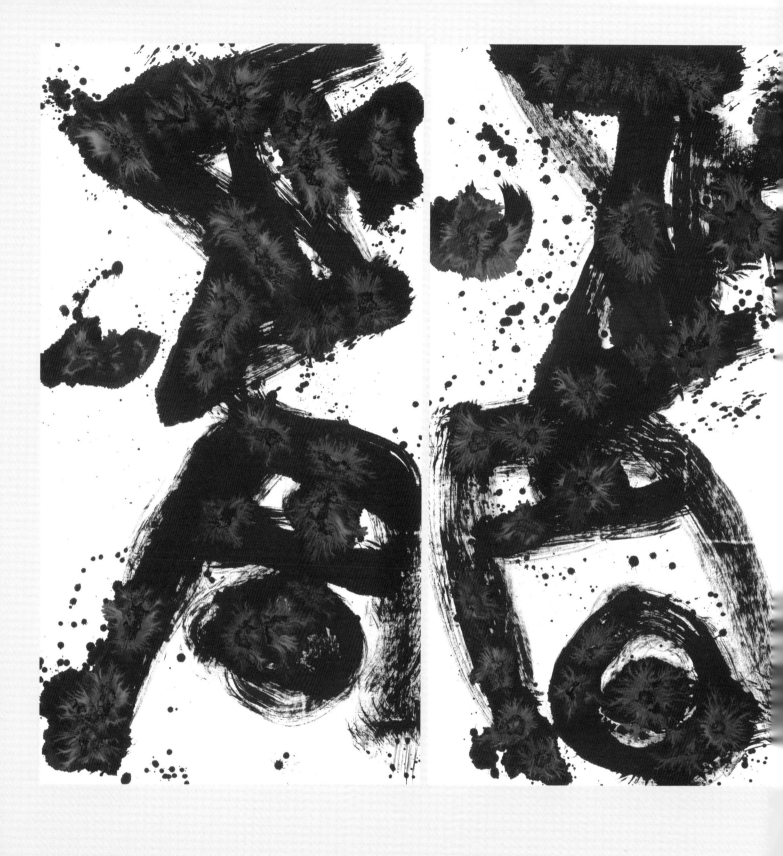

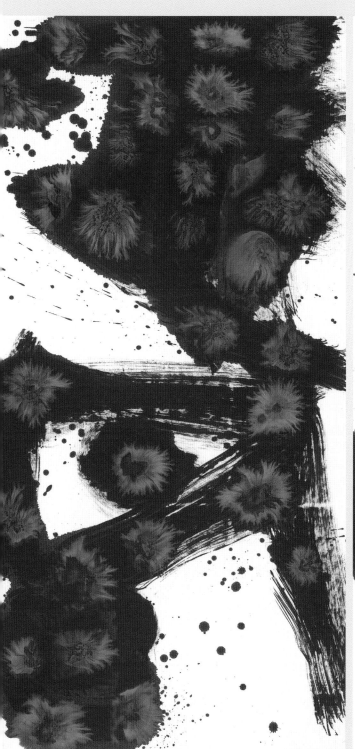
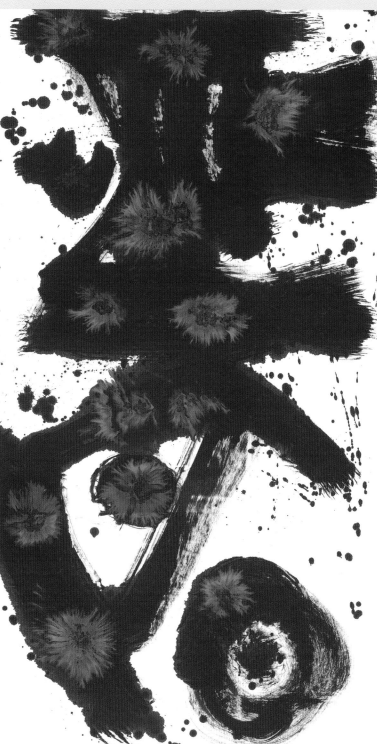

現代書藝 - 真明系列 180×90cm×4 2021

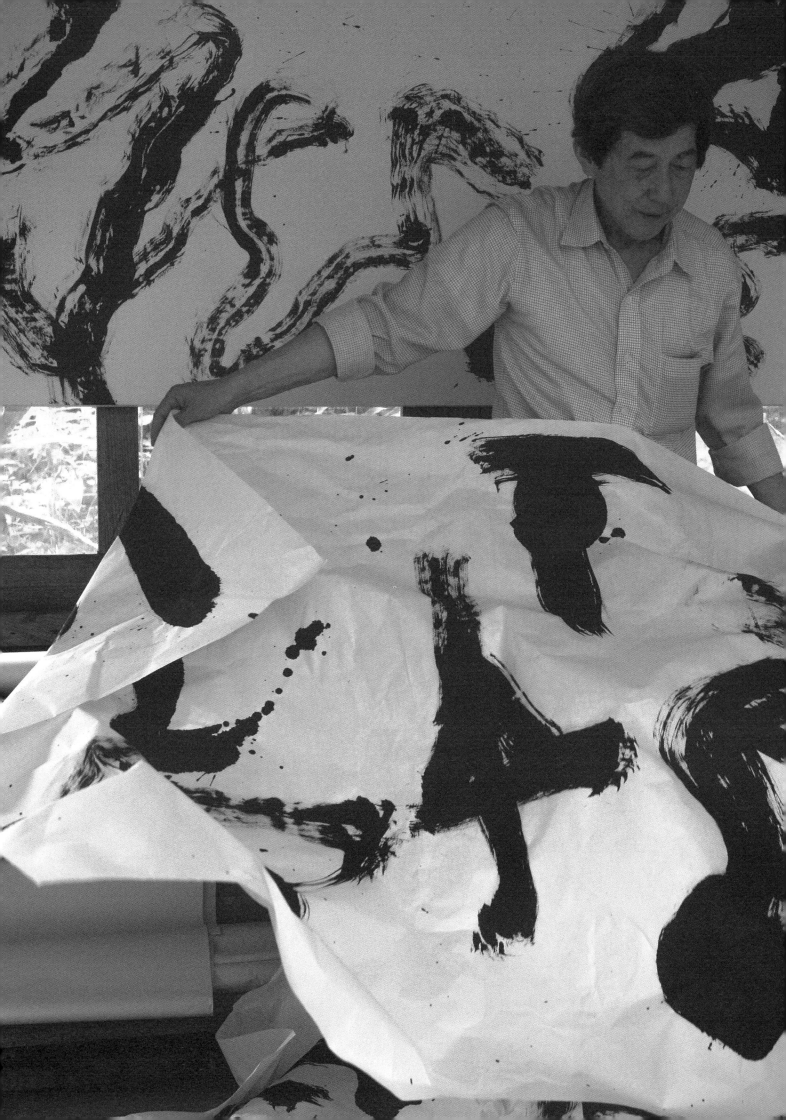

除了平面的抽象創作以外
吸取西方所謂的觀念藝術
而寫出的書法
是過程的產物
而這個過程本身就是一種趣味
一種想法

——————————————蔡明讚

臺灣書法三十年來，走過傳統與現代的轉型，跨越新舊世紀的隔閡，在二十一世紀的當代呈現多元紛呈的狀態，時代的禁忌隨著時空遞變而悄然逝去。在當代滿佈兩岸議題、國際趨勢的氛圍下，書法藝術環境已經習慣「沒有什麼實驗不可」、「非有傳統不行」的矛盾與辯證中，相安無事。

蔡明讚先生的成長、創作與影響，似乎成了臺灣三十年書法發展的縮影，也是臺灣書法豐盈的風景。如今蔡老師叮囑我寫篇序評，才驚覺到他已經六十五歲了。其實在大量書法推廣活動、競賽審查中，都能見到蔡老師身影，他總是神采奕奕地說到：「臺灣書法不靠咱們來推，靠誰來推……」他那種積極熱心的能量真是源源不絕，完全不似六十五歲的資深書法家；總是一貫洋溢著無限的青春氣息，也難怪乎其一頭濃密的頭髮，白髮不多，精力充沛，常令眾人艷羨！

順著此書寫因緣可以回望臺灣書法發展，觀照蔡老師的學習歷程，成為後疫時期關懷書法人文景致的一個開端。

蔡明讚又署適評，一九五六年生於臺灣桃園，一九七六年畢業於省立臺北師專，一九八二年畢業於中國文化大學中文系，一九九四年自國立臺灣師範大學國文研究所夜間班結業，曾任中華民國書法教育學會理事長，二〇一四年受邀進入換鵝書會，現為《書法教育月刊》社長，致力於書法教學與推廣。

一、書法因緣

明讚先生於桃園蘆竹鄉外社國小求學時期曾臨寫顏體，從此與書法結下不解之緣。七〇年代他就讀臺北師專時，開始涉獵各字體，此時亦師從張仁青教授學習古詩格律。師專畢業後，蔡明讚常和張建富拜訪換鵝書會會長黃篤生（1936—2012），亦曾拜訪「弘道書學會」創辦人陳其銓（1917—2003），讓他開闊書壇視野、增加傳統書學的知見。其於大學、研究所進修期間，持續蓄儲古典詩文含蘊；然於教育界服務期間，自以為因俗務羈身，詩作不多。一九八四年曾拜訪時任故宮書畫處研究員的張光賓先生（1915—2016），雖未正式拜學，然時常遊其門下，有師生之誼，於是光老樂善好施之人格風範，影響明讚先生甚多。其於中學任教之暇，對於書法更加孜孜矻矻，不忘其志，書寫不輟，如今四十餘年來廣涉於古典書法、現代書藝、理論著述、教育推廣等層面，成果豐盈。

蔡老師書學根基於長年精研歷代碑帖與名家法書，創作上篆、隸、草、行、楷各體皆能，經常也隨興揮灑，自成一格；近年著力於金文、隸書、草書字體甚深。尤其是金文的創作，因目前學界對於金文的理解更加多元，加上字典的輔助，因此以金文介入創作與書寫，不再困難，同時金文字形的自由性又可增加書法藝術的豐富性。其利用金文稚拙自然的書寫筆法與金文符號性的特點，強調字形結體的變化與設計，運用造形手法，表現個人化風格與具有視覺張力的效果。誠如他於〈春閒〉一作款識所言：「兩周鐘鼎銘文富結字變化，為造形創意之寶藏。」[1]、〈野曠‧觀物五律二首〉一作款識：「鐘鼎於商周乃家國之重器，其鑄刻之款識銘文……，故造形多姿，體勢豐贍，實書法創作取之不竭之寶庫。」[2]與〈筆法造形五言聯〉：「筆法貴精熟，造形非守窠。」[3]明讚先生認為金文為早期古漢字，寫法未受規範，書寫的隨意性，形成一字多

墨潮迭起‧適評一生——
蔡明讚先生的書藝歷程

形的情況，加上書者匠心可以讓文字造形有更大的發揮，如直線與曲線的變化、點線的對比、文字的穿插、筆畫迎讓等，使金文在質樸渾穆的風格中，在形式上又能別開生面。如〈筆法造形五言聯〉一作書寫率意、筆畫圓轉、線條粗細對比差異大、字體大小不一，錯落有致，顯得稚拙生動，可以看出蔡老師對於古文字的依戀情愫，以及其溫故知新的用心。

另外，明讚先生認為隸書表現以古雅樸拙為尚，尤其是漢隸因格調高古、點畫厚重，最能體現隸書樸厚古茂的藝術風格。如〈半隱·無題·夜課五律三首〉一作款識：「隸法以古樸為尚……習隸者先臨漢隸，次則參照諸名家，自能得趣。」[4]〈冬寒〉一作款識：「隸貴古樸，乃所謂金石趣也，常見作隸寫家但期整飭，則形勢失矣。」[5]〈習游〉一作款識：「隸書以漢人書碑為最有意趣，清人則筆墨可法也。」[6]蔡明讚的隸書取法兩漢隸法，包括〈張遷碑〉、〈鮮于璜碑〉、〈石門頌〉、〈西狹頌〉等，近學清代鄭簠、陳鴻壽、呂世宜、何紹基並自出己意，因此用筆澀勁、結體靈活多變、欹正錯落，風格自然率性，同時將篆書結構融入隸書，化圓為方，增益其造形變化，展現草隸之間的多種面貌。

草書因其文字造形變化自由，及書寫胸中逸氣之特點，草書因此也成為蔡老師最善於表現的字體。其草書運筆放縱、善用點畫的呼應與對比、筆勢連綿，章法參差錯落，從中可窺見懷素與祝枝山的影響；尤其橫幅的作品因字數較少，且文字欹正、穿插、挪讓，變化更為豐富，突破行與行的限制、畫面中點畫狼藉、虛實相生，使其橫幅作品較直幅作品更具節奏感與表現性，特別是經常即席揮寫自撰之詩文，落筆雲煙，怪狀合宜之處世人所不及。

二、書藝墨潮

一九七六年以相容傳統與現代為理念的墨潮書會成立。一九八三年五月蔡明讚與張建富、廖燦誠、程代勒、徐永進等人成立「現代書藝盟」，以促進現代書法藝術創作內涵為目標，六月於國軍文藝活動中心舉辦「仲夏的墨韻－現代書藝七人展」。一九八五年十一月「現代書藝系列展」蔡明讚為參展成員之一，此展突破平面性作品的限制，展出括裝置、戶外創作等跨領域的作品。一九八五年《書法藝術》季刊創刊，明讚先生為主編，是臺灣在解嚴前大量介紹「現代書法」相關論述的雜誌。八〇年代蔡明讚的書法創作強調字形變化與畫面構成；其現代書藝作品則重視繪畫性，強調文字的象形性，或以金文、小篆入書，以墨色、色彩加強畫面的對比與變化。

之後，墨潮書會雅集暫停，一九八八年復會，同年「蔡明讚、陳明貴書畫雙人展」。一九八七年臺灣地區解嚴後大陸政策隨之開放，一九八八、一九八九年墨潮會成員張建富、陳明貴、蔡明讚等人開始與中國大陸的美術團體進行書法交流。一九九二年蔡明讚應邀參加韓國漢城舉行「九二漢城國際現代書藝大展」。一九九二年十月墨潮會於臺北快雪堂藝術中心舉辦書藝創作展，蔡明讚為參展的核心成員之一。

一九九三年四月臺北摩耶畫廊舉辦「現代書藝十年回顧展」，蔡明讚亦參展。同年八月墨潮會於《藝術家》雜誌以專欄的形式開闢「現代書藝論壇」，蔡明讚任總執事，至一九九五年累計刊載數十萬字的現代書藝相關資訊，包括大量現代書藝創作圖版資料。一九九三年八月墨潮會於國立國父紀念館進行「現代書藝表演」的戶外行為，表現現代書藝的展演特質與書法行為化的探

明讚，《留金寄興－蔡明讚金文集》，蕙風堂墨有限公司出版部，2017年1月，頁29。

明讚，《留金寄興－蔡明讚金文集》。

明讚，《留金寄興－蔡明讚金文集》，頁49。

明讚，《著隸抒懷－蔡明讚隸書集》，頁13。

明讚，《著隸抒懷－蔡明讚隸書集》，頁21。

明讚，《著隸抒懷－蔡明讚隸書集》，蕙風堂墨有限公司出版部，2017年1月，頁11。

索。一九九四年六月「墨潮聯展」展於臺灣省立美術館，並出版《現代書藝》一書。

　　九○年代墨潮會企圖在創作、媒材及表現形式上彰顯觀念表述，大量引用他類藝術觀念進行現代書藝創作與理論。一九九三年之後，墨潮會所發表的現代書藝作品，可概分為平面作品與立體作品。蔡明讚曾說明墨潮會藝術創作的目標：「未來的目標是結合現代藝術觀念，轉化傳統書藝理論，探討一切『表現』的可能性，運用一切素材去創作，把『現代書藝』提升成為國際藝術的「新流派」[7]。以及「現代書藝的『符號表現』是藉著各種有義（文字、泛文字、泛書法）或無義（記號）的古今符號結合其他媒材來表現現代書藝家感知於「一切」而興起的自發性藝術創作理念。」[8]墨潮會的現代書藝創作企圖突破傳統書法平面書寫的限制，顛覆了舊有的審美標準，從二維展示擴張到三維的立體作品的呈現，開啟書法審美的現代性意義，對於臺灣當時保守、傳統的書法環境而言，無疑有激活的作用。此時期蔡明讚的複合媒材或裝置作品，表現出文字書寫的多樣化，帶有濃厚的繪畫性實驗特質。

　　墨潮會在七○年代應運而生，並在九○年代積極活動與發展，九○年代中後期墨潮會之大型展演活動漸少，直至二○○一年六月舉辦「墨潮創會二十五周年新世紀大展—前衛、現代、超ㄅㄧㄤˋ」一展於何創時書藝館。之後墨潮會已經沒有公開的盛大活動與展出，墨潮會重要的成員中，仍持續創作者不多，明讚先生成為兼具傳統與現代性創作之代表。其近年的現代書藝作品回歸書法的書寫性表現，以墨韻變化取代色彩表現，內容以傳統經典或自作詩句為主，其創意表現主要是在不同字體的雜合與文字造形的變化上。如二○一八年〈聽禪戲墨〉一作，揉合草書、篆書，兩字之間的字距極小，加上畫面中飛白用筆與淡墨的對比，表現出書法線條之抽象性。二○一九年〈德不孤〉一作，內容為《論語》的「德不孤，必有鄰。」書體以篆書為主，蔡老師以重墨書寫，文字大小穿插與造形的誇張變化，同時兩字之間的字距幾乎消失，使整幅畫面為一完整結構，表現出塊面與線條的平面構成，將視覺設計原理與傳統筆墨功夫交織表現。

三、教育推廣

　　蔡明讚先生於八○年代開始參與各項推廣書法教育的工作，一九八六年至二○一二年任臺北市師範學院書法社指導教師；而他從中正國中教師職務退休之後，二○○一年起更投入社區大學的書法賞析與習作課程。二○○二年起任第十二、十三屆中華民國書法教育學會理事長，二○一一年起任《書法教育月刊》社長，致力於現代書藝及書法教育推廣活動。歷任蕙風堂碑帖叢書主編，全國學生美展、中山青年藝術獎等大量書法競賽之評審委員。

　　八○年代明讚先生已經擔任《書法藝術》季刊主編，九○年代墨潮於《藝術家》雜誌以專欄的形式開闢「現代書藝論壇」，他發表大量現代書藝相關論述，提倡現代書藝。他亦曾肩負目前書法刊物發行量最大的《書法教育月刊》主編，報導臺灣書壇及書畫篆刻相關新聞、展覽資訊、學術研討、學會、獎賽活動等資訊，讓月刊成為最為普及閱讀的流行刊物，也成為攏聚書法界資源的重要平台。

　　明讚先生對於推廣書法教育有著強烈的使命感，他曾多次參與書法師資培訓研習教席、書法刊物編輯、書法創作展覽、國際書法交流活動等，並曾出版《中國書法史新論》、《國民小學書

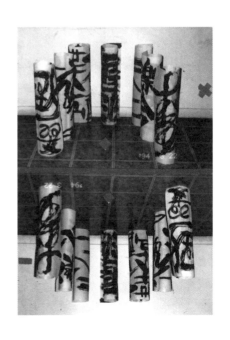

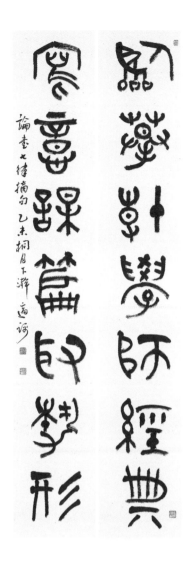

法課本》、《書法的趣味》、《書法·讚》、《興懷藝情－蔡明讚詩書集》、《澤毫萃墨：蔡明讚詩書集》及書畫藝術相關論述三百餘篇。他以推廣書法教育與傳承書法藝術當成終身志業，對於臺灣書法發展與文化傳承具有深遠意義與貢獻。

四、詩文天地

明讚先生早年為現代書藝的悍將，一路從實驗性創作跨足現代書藝的觀念表述，創作兼及平面與立體，引領時代改革，為墨潮會的代表人物。然隨著臺灣書法創作環境的轉變與個人年齡增長，其創作方向明顯偏向詩人的游藝性，蔡老師現在偏好詩文創作，透過詩作，似乎更能找到自己安身立命的書道之路。如〈秋郊向晚〉款識：「詩書閒暇事，心適而為之，然亦可述志抒情並說理也。」[9] 由於暮年心境的轉變，明讚先生也嚮往禪學的形上境界；與經歷了現代書藝強化觀念性、視覺表現性以及運用各種媒材創作的實驗過程之後，其書法最終向傳統底蘊回歸，二○○七年蔡明讚開始以詩入書，十餘年間近體詩的創作，已逾千首之數；雖然他現在的作品偶有創新意識，但更多的時候，他的作品服膺在詩文裡，彰顯文人風雅的追求。他以詩文創作，言志抒情，作為他書藝表現的另一個高度，也充分發揮了自己的才華，縱橫在詩書之間而怡然自得。

五、結語

明讚先生認為「研學書法大抵有五個進程－臨摹、臨書應用、自運、創作、前衛。」[10] 可知「前衛」書法為其研學書法之最終目標。於是「創新」是他始終如一的創作趨力，他以草書、篆書揉合與字形變化作為他追求前衛表現的新形式，由此他又區分現代書藝、破體書、少字數造形、寫意造形、造形書藝等。誠如他的〈臨摹寫意七言聯〉：「臨摹博學師經典，寫意謀篇取勢形。」[11] 與〈金文五言聯〉：「寫意質文氣，造形奇變玄。」[12] 可知文字造形的運用與變化是他區隔傳統書法的主要方式，也是他創意展現重要媒介，由此衍生不同的形式展現，這是他長年來精研習寫的成果。

書法雖然是一種視覺藝術的表現，也是人文底蘊的開展，更是生命價值的體現。蔡老師人書漸老，生命歷練越深，書藝形式更偏向與古為徒，借古開新的擺盪，但總是下筆渾然，自有我在，似乎也不是古與今，新與舊的辯證可以盡述了。這些回顧與觀察，在在流露出書法藝術豐盈的內涵，相信蔡老師在六十五歲的書藝展中，必是古今交會，滿壁縱橫，以饗書壇。

華梵大學人文與藝術學院院長

黃智陽

□評，〈現代書藝〉，《藝術家》（臺北：藝
□家雜誌社，1993 年 6 月），總號 217，456 頁。

□明讚整理，〈現代書藝「符號表現」之探討〉，
《藝術家》（臺北：藝術家雜誌社，1994 年 1
□），總號 224，408 頁。

□明讚，《著隸抒懷－蔡明讚隸書集》，頁
□。

□明讚，《揮草游藝－蔡明讚草書集》，蕙風
□筆墨有限公司出版部，2017 年 1 月，頁 5。

□明讚，《留金寄興－蔡明讚金文集》，頁
□。

□明讚，《留金寄興－蔡明讚金文集》，頁
□。

In the past thirty years, calligraphy in Taiwan has transformed from tradition to modernity and crossed the border between the old and new era. In the diverse 21st century, the past taboos have also evaporated with the time. In the contemporary atmosphere full of cross-strait issues and international trends, the environment of calligraphy art has adapted well to the conflict and argument between "there is nothing that can't be experimented with" and "there has to be tradition."

Mr. Tsai Ming-tzann's growth, creation, and influence seem to become the microcosm of the calligraphy development in Taiwan in the past thirty years as well as the rich scenery of calligraphy in Taiwan. When Mr. Tsai asked me to write a commentary for him, I suddenly realized that he had been sixty-five years old. In fact, I often saw Mr. Tsai at a large number of promotional activities and competitions of calligraphy, and he always said energetically, "Who will promote calligraphy in Taiwan except for us?" With the endless active and enthusiastic energy, he doesn't look like a senior calligrapher at the age of sixty-five at all. With thick hair, little white hair, and full energy, he is admired by us for the unlimited youthful spirit!

Through this writing experience, I will look back on the calligraphy development in Taiwan by referring to Mr. Tsai's learning process. This article may serve as a start to appreciate the cultural landscape of calligraphy in the post-epidemic era.

Mr. Tsai Ming-tzann, also called Shi-ping, was born in Taoyuan, Taiwan, in 1956. He graduated from Provincial Taipei Teachers' College in 1976, Department of Chinese Literature, Chinese Culture University in 1982, and Graduate Institute of Chinese, National Taiwan Normal University in 1994. He used to be the chairman of The Republic of Chinese Society for Calligraphy Education. He was invited to join Huan E Calligraphy Society in 2014. At present, he is the president of the monthly, Calligraphy Education, devoted to calligraphy education and promotion.

I. Connection with Calligraphy

When studying in Wai She Elementary School, Luzhu Township, Taoyuan, Mr. Tsai imitated Yan Zhen-qing's calligraphy style, which was the start of his connection with calligraphy. When studying in Taipei Teachers' College in the 70s, he started to be exposed to the different styles and learned the metrics of old poems from Prof. Zhang Ren-qing. After graduation, Mr. Tsai often visited the president of Huan E Calligraphy Society, Huang Du-sheng (1936-2012), together with Zhang Jian-fu. They also visited the founder of Hung Dao Calligraphy Association, Chen Qi-qian (1917-2003), which broadened his horizons in the calligraphy circle and enriched his knowledge about traditional calligraphy. During his advanced study in university and graduate school, he continued to enhance the literacy of classical poetry. However, when working as a teacher, he didn't write many poems because of the heavy duty. In 1984, he visited Mr. Zhang Guang-bing (1915-2016), who was the researcher of Department of Calligraphy and Painting, National Palace Museum, at that time. Though he didn't become an official apprentice of Mr. Zhang, he often paid a visit and hence built the teacher-student relationships with the senior. Therefore, Mr. Zhang's personal traits of benevolence had deep influence on Mr. Tsai. He made use of the spare time

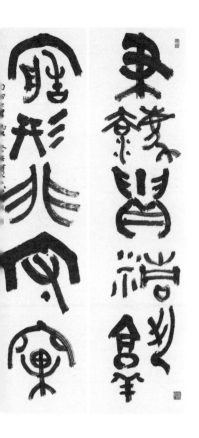

of the teaching post in high school and kept writing calligraphy diligently without forgetting his aspiration. For more than forty years, he has widely dabbled in classical calligraphy, modern calligraphy, theories, education, and promotion of calligraphy and made great achievements.

Based on his careful research of the ancient stele inscriptions and famous calligraphers' writing for long years, Mr. Tsai's calligraphy excels in all scripts including seal script, clerical script, cursive script, running script, and regular script. He also often writes freely with his unique style. In recent years, he has been more devoted to the bronze script, clerical script, and cursive script, especially the creation of the bronze script. As the present academia has the more diverse understanding about the bronze script and the support of dictionaries, it is not difficult to introduce the bronze script into creation and writing any more. At the same time, the freedom of the bronze script can add variety to calligraphy art. By making use of the unadorned and natural writing techniques and the symbolic characteristic of the bronze script, he emphasizes the variety and design of the character structure and expresses the personalized style and effects with visual tension with the design techniques. As he said in the work of "Spring Leisure," "The bronze script in Zhou Dynasty full of the varieties of the character structure is the treasure of design creativity."[1] In the two poems in five-character regulated verse, "Open Wildness," he wrote, "In Shang and Zhou Dynasty, bronzes are the important tools engraved with inscriptions . . . The various designs and abundant styles are the endless trove of calligraphy creation."[2] In "Five-character Couplet of Brush Stroke Style," he wrote, "It is important to be skillful in the brush strokes and not be conservative with the styles."[3] Mr. Tsai believes that the bronze script belongs to the ancient Han characters. The freedom of the unregulated writing leads to the situation of one character in multiple forms. Besides, the calligrapher's artisanship will give the character style full play, such as the changes of straight and curved lines, contrast between dots and lines, interlaced texts, and harmonization of strokes. Therefore, in the simple and mild style of the bronze script, he can create a new pattern. For example, in "Five-character Couplet of Brush Stroke Style," the free writing, round strokes, large contrast between thick and thin lines, and characters in different sizes are well proportioned, looking unadorned and vivid. It can be found that Mr. Tsai has had the deep love for ancient characters and paid attention to gain new insights by reviewing what has been learned.

Moreover, Mr. Tsai considers it better to present the clerical script in an elegant and unadorned way, especially the clerical script in Han Dynasty. The elevated style and heavy strokes reflect the simple and splendid artistic style of the clerical script most. For example, in "Half Secluded, Untitled, Three Five-Character Poems of Night Class," he wrote, "The clerical script should follow simplicity . . . The clerical script learners should imitate the clerical script in Han Dynasty and then refer to other famous calligraphers so as to enjoy themselves."[4] In "Winter Coldness," he wrote, "Simplicity counts in the clerical script. It is the so-called charm of the stone inscriptions. It is common that the clerical script writers expect to make some changes but end up losing the spirit of it."[5] In "Xi You", he wrote, "In terms of the clerical script, the stele inscriptions of Han Dynasty are most interesting and charming. As for the use of brush and ink, the works of Qing Dynasty are worth imitating."[6] Mr. Tsai's clerical script follows the techniques of Han Dynasty, including "Stele of Zhang Qian," "Stele of Xianyu Huang,"

i Ming-tzann. Tsai Ming-Tzann Bronze Script lection. Hui Feng Tang Publishing Ltd., January 7, P.29

i Ming-tzann. Tsai Ming-Tzann Bronze Script lection.

Ming-tzann. Tsai Ming-Tzann Bronze Script lection. P.49

Ming-tzann. Tsai Ming-Tzann Clerical Script lection, P.13

Ming-tzann. Tsai Ming-Tzann Clerical Script ection, P.21

Ming-tzann. Tsai Ming-Tzann Clerical Script lection, Hui Feng Tang Publishing Ltd., January 7, P.11

"Ode to Shimen," and "Ode to Xixia." In Qing Dynasty, Zheng Fu, Chen Hong-shou, Lu Shi-yi, and He Shao-ji added their own styles. Through the strokes with strength, structure with flexibility, radicals of proper proportion, and natural and freehand styles, they combined the structure of the seal script into the clerical script, squared the circles, and added the changes to the style to show the different looks between the cursive and clerical scripts.

Featuring the freedom of making changes in character styles and the expression of freedom in mind, the cursive script has become the script Mr. Tsai excels in most. There are no restraints to the use of brush in writing the cursive script. He makes good use of the support and contrast from dots, connected strokes, and uneven and disorderly organization. The influence from Huai Su and Zhu Zhi-shan can be found in his works. Among them, the horizontal works with fewer characters have more varieties in structure, interlacing, and transfer, breaking the borders between lines and creating the coexistence of the concrete and the fictitious with the disorderly dots in the picture. His horizontal works have more rhythm and performance than vertical ones, especially the impromptu self-written poems with the smooth strokes and incomparable odd perfection.

II. Calligraphy Art of Mo Chao Hui

In 1976, Mo Chao Hui, the calligraphy society with the concept of integrating tradition and modernity, was established. In May 1983, Tsai Ming-tzann established Modern Calligraphy Art Alliance together with Zhang Jian-fu, Liao Can-cheng, Cheng Dai-le, and Xu Yong-jin to pursue the goal of enhancing the creative content of modern calligraphy art. In June, "Ink Charm in Summer: Seven Artists Joint Exhibition of Modern Calligraphy Art" was held at Armed Forces Cultural Center. In November 1985, Tsai Ming-tzann was one of the participating artists of "Modern Calligraphy Art Series Exhibition." The exhibition broke through the limit of graphic works and exhibited the interdisciplinary works including installation art and outdoor creation. In 1985, the quarterly, Calligraphy Art, was started, and Mr. Tsai was the editor in chief. It was the journal with plenty of introductory discourses to "modern calligraphy" before the lifting of martial law in Taiwan. In the 80s, Mr. Tsai's calligraphy creation emphasized the character variety and image composition. His modern calligraphy works focus on the painterly style and pictographic characteristic of characters. The bronze script and small seal script are used in calligraphy, and ink colors are applied to strengthen the contrast and variety of the picture.

Afterwards, the gatherings of Mo Chao Hui was suspended and resumed in 1988. In the same year, "Tsai Ming-tzann and Chen Ming-gui Calligraphy and Painting Exhibition" was held. In 1987, the mainland policy was opened after the lifting of martial law in Taiwan. In 1988 and 1989, the members of Mo Chao Hui, Zhang Jian-fu, Chen Ming-gui, and Tsai Ming-tzann started the calligraphy exchange with the fine arts groups in Mainland China. In 1992, Tsai was invited to join in "1992 International Modern Calligraphy Art Exhibition in Seoul," held in Korea. In October 1992, Mo Chao Hui held the calligraphy art creation exhibition at Kuai Xue Tang Art Center in Taipei, and Tsai Ming-tzann was one of the core members of the exhibition.

In April 1993, Mo Ye Gallery in Taipei held "Ten Years of Modern Calligraphy Art Retrospective

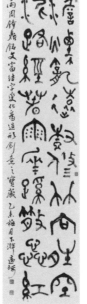

Exhibition," Tsai Ming-tzann was one of the artists. In August of the same year, Mo Chao Hui opened a column of "Modern Calligraphy Art Forum" in the magazine, Artist, and Tsai was in charge. It published the information related to modern calligraphy art of hundreds of thousands of characters until 1995, including a large number of creative patterns of modern calligraphy. In August 1993, Mo Chao Hui held the outdoor activity of "Modern Calligraphy Art Performance" at National Dr. Sun Yat-sen Memorial Hall, exploring the exhibition characteristics and calligraphy behavior of modern calligraphy art. In June 1994, "Mo Chao Joint Exhibition" was held at Taiwan Museum of Fine Arts and the book, Modern Calligraphy Art, was published.

In the 90s, Mo Chao Hui attempted to highlight the conceptual expression in terms of creation, media, and expressive forms and cited a large number of concepts in other art categories in the modern calligraphy works and theories. After 1993, the modern calligraphy works published by Mo Chao Hui could be generally divided into the graphic and 3D ones. Tsai once explained Mo Chao Hui's goal in art creation: "The future goal is to combine the concept of modern art, transform the traditional theories of calligraphy art, discuss all possibilities of 'performance,' and apply all materials in creation to upgrade 'modern calligraphy art' to a 'new sect' of international art." [7]He also said, "The 'symbolic performance' of modern calligraphy art is to express modern calligraphers' spontaneous concept of art creation rising from 'everything' of their perception by combining other media through all kinds of ancient and modern meaningful (word, text, and calligraphy) or meaningless (symbols) signs."[8]Mo Chao Hui's modern calligraphy creation attempted to break through the limit of the graphic writing of traditional calligraphy and subvert the existing aesthetic standard. From the 2D display expanded to the 3D presentation, the modern meaning of calligraphy aesthetics was created. There was undoubtedly the inspiring function to the conservative and traditional calligraphy environment in Taiwan at that time. In that period of time, Tsai's works of mixed media and installation art showed the diversity of writing and the rich experimental characteristic of painting.

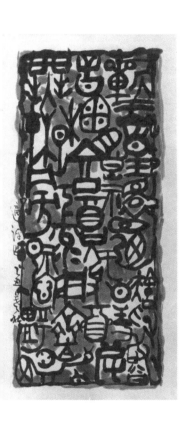

Mo Chao Hui was established in the 70s and active and developing in the 90s. In the mid and late 90s, there were fewer large exhibitions. In June 2001, "The 25th Anniversary New-Century Exhibition of Mo Chao Hui: Avant-Garde, Modern, and Cool" was held at HCS Calligraphy Foundation. Afterwards, there were no public events and exhibitions. Among the important members of Mo Chao Hui, there were few artists keeping creating new works. Mr. Tsai became the representative with both traditional and modern creation. His modern calligraphy works in recent years have returned to the writing performance of calligraphy. The changes of ink charm have replaced the performance of colors. The contents are mainly the traditional classic works or self-made poems. His creative performance mainly lies in the mixture of the different scripts and the changes of character styles. For example, "Listen to Zen and play with Ink" in 2018 combines the cursive script and seal script with the extremely small gap between two characters. The contrast between the Fei Bai technique and light ink in the picture reveals the abstractness in the lines of calligraphy. In, "Virtue Not Alone" in 2019, "virtue never stands alone and is bound to have neighbors" is quoted from The Analects and mainly written in the seal script. Mr. Tsai wrote with heavy ink and made exaggerated changes to character

Shi-ping. "Modern Calligraphy Art." Artist. ei: Artist Magazine. June 1993, No.217, P.456

anized by Tsai Ming-tzann. "Discussion on the nbolic Expression' in Modern Calligraphy Art." st. Taipei: Artist Magazine. January 1994. No.224, 8

sizes and styles. At the same time, there is even no spacing between characters, which makes the overall picture of a complete structure, shows the plane composition of blocks and lines, and displays the visual design principles and traditional ink techniques together.

III. Education and Promotion

Mr. Tsai started to engage in a variety of promotions of calligraphy education from the 80s. From 1986 to 2012, he served as the teacher of the calligraphy club in Taipei Teachers' College. After retiring from the teaching post in Zhong Zheng Junior High School, he started to teach the course of Calligraphy Appreciation and Practice in community universities from 2001. From 2002, he served as the 12th and 13th Chairman of The Republic of Chinese Society for Calligraphy Education. From 2011, he became the president of Calligraphy Education, devoted to the promotions of modern calligraphy and calligraphy education. He was the editor in chief of the stele inscription books of Hui Feng Tang and the judge of many calligraphy competitions including National Student Art Competition and Chungshan Youth Art Award.

In the 80s, Mr. Tsai served as the editor in chief of the quarterly, Calligraphy Art. In the 90s, Mo Chao Hui opened a column, "Modern Calligraphy Art Forum" in the magazine, Artist. He published a large number of discourses related to modern calligraphy and promoted modern calligraphy. He also shouldered the responsibility of the editor in chief of Calligraphy Education, the monthly with the present largest circulation of calligraphy publication reporting the information of the calligraphy, painting, and seal carving circles in Taiwan including the related news, exhibitions, academic conferences, associations, competitions, and activities and making the monthly the most popular journal and important resource-collecting platform in the calligraphy circle.

Mr. Tsai has the strong sense of mission in promoting calligraphy education. He frequently taught at the calligraphy teachers training programs, served as the editor of calligraphy journals, and joined in the calligraphy exhibitions and international calligraphy exchanges. He published A New Theory of Chinese Calligraphy, Elementary School Calligraphy Textbook, The Fun of Calligraphy, Calligraphy, So Great, Xing Huai Yi Qing: Collection of Tsai Ming-tzann's Poetry and Calligraphy, Ce Hao Cui Mo: Collection of Tsai Ming-tzann's Poetry and Calligraphy, and more than 300 articles on calligraphy and painting. He treats it as his lifelong career to promote calligraphy education and pass on calligraphy art and brings the deep meaning and contribution to the calligraphy development and cultural heritage in Taiwan.

IV. Poetic and Literary World

In the early years, Mr. Tsai was a pioneer of modern calligraphy. As a representative figure of Mo Chao Hui, he led the renovation all the way from the experimental creation to the conceptual expression of modern calligraphy through both graphic and 3D works. However, as the environment of calligraphy creation in Taiwan changes and Mr. Tsai gets older, his creative direction has evidently focuses more on the poet's leisurely fun. At present, Mr. Tsai prefers to write poems and seems to settle down and find his way of calligraphy through poetry writing. For example, he wrote in "Evening Autumn Trip," "I write poems and calligraphy

at leisure when I'm in a good mood. Writing poems is the way to express my ambition, feelings, and argument." [9]With the changes in mind at an old age, Mr. Tsai also aspires the metaphysical level of Zen. After experiencing the experimental process of strengthened conceptualization, visual performance, and application of all kinds of media of modern calligraphy, his calligraphy finally returns to the traditional heritage. In 2007, Mr. Tsai started to write poems in calligraphy works. He has accumulated more than thousand metric poems in the past over ten years. There are occasionally innovative attempts in his present works. However, most of the time, his works highlight the pursuit for the literati's elegance in poetry. He expresses his aspiration and feelings in the poetic creation and reaches another level of calligraphy art, fully exerting his own talents and finding great pleasure in poetry and calligraphy.

V. Conclusion

Mr. Tsai believes "there are generally five steps in learning calligraphy—imitation, application, self-writing, creation and innovative development." [10]This indicates that the "innovative development" of calligraphy is his ultimate goal in learning calligraphy. Therefore, "making innovations" has always been his creative power. By combining and making changes to the character styles of the cursive script and seal script, he pursues the innovative performance in a new way. He also categorizes modern calligraphy, blend-style calligraphy, less-character style, expressive style, and style calligraphy art. As he wrote in "Seven-Character Couplet of Expressive Imitation," "Learn widely from the classic works through imitation and inner expression of the spirit of the style." [11]In "Five-Character Couple of the Bronze Script," he wrote, "The momentum of the writing lies in the expressive quality as the style could be of strangeness and variety." [12]It can be understood that the application and variety of character styles is the major way for him to separate from traditional calligraphy as well as the important medium for him to show creativity. Therefore, the display of the different forms is the result of his careful research and practice for years.

Calligraphy is an expression of visual art, the expansion of cultural heritage, and the manifestation of life value. As Mr. Tsai grows older together with his calligraphy, he has accumulated more life experience. His calligraphy art tends to linger between following the ancient works and creating something new based on the ancient works. However, there is the personal style in his natural and perfect writing, which looks neither ancient nor modern but fully displays the essence of the old and the new. The retrospect and observation reveal the rich content of his calligraphy art. It is believed that the great works full of ancient and modern charm of calligraphy will be a feast to the calligraphy circle in Mr. Tsai's calligraphy exhibition at the age of sixty-five.

Dean of the College of Arts and Design, Huafan University

Huang Chih-Yang

Ming-tzann. Tsai Ming-Tzann Clerical Script lection. P.43

ai Ming-tzann. Tsai Ming-Tzann Cursive Script ollection. Hui Feng Tang Publishing Ltd., January 17, P.5

ai Ming-tzann. Tsai Ming-Tzann Bronze Script ollection. P.57

ai Ming-tzann. Tsai Ming-Tzann Bronze Script ollection. P.29

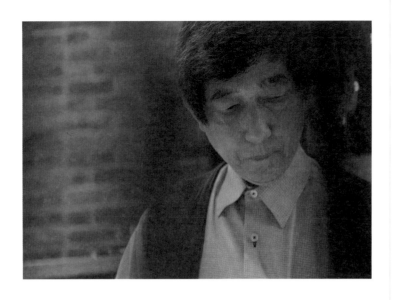

1956・生於臺灣桃園。
1983・現代書藝七人展（臺北・國軍文藝活動中心）。
1985・現代書藝系列展四檔（臺北・神羽畫廊）。
1985・任《書法藝術》季刊總編輯、《書法教育》期刊、會訊主編
1986・任臺北市立師範學院書法社指導老師（迄二○一二）。
1988・韓中國際書法教育研討會論文發表（韓國漢城）。
1989・任蕙風堂碑帖叢書主編。
1990・出版《中國書法史新論》（蕙風堂發行）。
1992・應邀九二漢城國際現代書藝展（藝術殿堂）。
1993・墨潮會於《藝術家》月刊開闢現代書藝論壇，任總執事。
1994・墨潮會聯展（八人）（臺中・國立臺灣美術館）。
　　　・出版《國民小學書法課本》（與詹吳法、連德森合著，蕙
　　　　堂發行）。
1995・本年起擔任各種書法比賽評審委員（縣市語文競賽、美展
　　　　金鵝獎、金鴻獎、磊翁盃、金輪獎、慈龍盃、明宗獎、行
　　　　宮人文獎、書法春秋大賽……等全國書法比賽）。
1999・何創時書法基金會、滄浪書社合辦蘭亭序國際學術研討會
　　　　分場主持人（蘇州）。
2000・應邀何創時傳統與實驗雙年展（歷屆應邀）。
　　　・出版《書法的趣味》（蕙風堂發行）。
2001・墨潮會新世紀大展（七人）（臺北・何創時書法藝術館）
2002・任中華民國書法教育學會第十二、十三屆理事長。
2003・本年起應淡江大學、華梵大學、臺灣藝術大學、臺灣師範
　　　　學、明道大學、書法教育學會……等主辦之書法學術研討
　　　　發表論文十餘篇。
2004・率團訪韓參加「韓中書法教育交流三十周年紀念特展」暨
　　　　談會。
2005・應邀國際現代書藝展（筆墨的擴散）（韓國首爾・物波畫廊）
2006・應聘臺南大學書法才藝教師研習班講座。
　　　・文化總會出版「臺灣藝術經典大系」書法藝術卷專文介紹

蔡明讚 適評
Tsai Ming-Tzann

2007‧紀念傅狷夫現代書畫藝術學術研討會論文發表（臺灣書法寫意現象探討）。

2008‧應邀華梵大學「書法與文化國際學術研討會」論文發表（八〇年代以後的臺灣書法文化）。

2009‧臺北市第五屆漢字文化節應邀專題展（臺北‧華山藝術園區）。

2010‧首屆兩岸漢字藝術節應邀參展及論文發表（北京（之後歷屆應邀參與））。

2011‧任《書法教育月刊》社長。
　　‧應邀高雄明宗書法藝術館舉行個展。

2012‧應邀韓國釜山國際書法雙年展、全北國際書法雙年展。
　　‧第三屆兩岸漢字藝術節名家書法展（山東‧棗莊）。
　　‧臺、美、加書法聯展（加拿大多倫多、美國洛杉磯、臺東生活美學館）。

2013‧第十三屆行天宮人文獎書法評審。
　　‧樹衛時代—傳統與實驗書藝雙年展（高雄市立美術館）。

2014‧墨海社六人首展（臺北‧國軍文藝活動中心）。
　　‧第五屆兩岸漢字藝術節名家書法展（江蘇‧常熟）。
　　‧游藝與承傳—換鵝會四十年書法展（高雄‧明宗書法藝術館）。

2015‧墨海社六人展（高雄市立文化中心、國立臺南生活美學館）。
　　‧國立臺灣藝術教育館「書法讚」系列活動策展委員，並撰寫《書法讚》專書（與施伯松合著）。
　　‧應邀何創時傳統與實驗雙年展（高雄市立美術館）。

2016‧墨海社六人展（桃園市文化局中壢藝術館、臺中市大墩文化中心）。
　　‧應邀第七屆兩岸漢字藝術節名家書法展（貴州省貴陽市）。
　　‧擔任一〇五年全國學生美展書法評審委員。
　　‧擔任國立國父紀念館「中山青年藝術獎」書法評審委員。

2017‧《興懷藝情—蔡明讚詩書集》新書發表暨書法作品展（臺北‧何創時書法藝術基金會）。
　　‧墨海社書法展（高雄市明宗書法藝術館、基隆市文化中心）。

2018‧擔任國立國父紀念館展覽審查委員。
　　‧芝友墨緣—北師校友十三人展（高雄‧明宗書法藝術館）。

2019‧人間衛視「創意多腦河」節目黃子佼主持專訪。
　　‧應聘國立國父紀念館審議委員。
　　‧策劃換鵝會四十五周年《換鵝書法家》（長歌藝術傳播發行）新書發表暨展覽（臺北‧何創時書法藝術基金會）。
　　‧策畫「鵝語錄」換鵝會書法展（臺北‧友生昌藝術空間、臺南‧懷雅文房）。
　　‧墨海社書法展（臺北‧國立國父紀念館博愛藝廊）。
　　‧何創時傳統與實驗雙年展（高雄市立美術館）。

2020‧第十屆兩岸漢字藝術節名家書法展（國立國父紀念館）。
　　‧任一〇九學年度全國學生美展書法評審。
　　‧墨海社九人展（臺北‧國軍文藝活動中心）。

2021‧金門縣書法學會邀請專題演講。
　　‧欣逢墨緣—墨海社九人展（臺中‧逢甲大學游翰堂）。
　　‧任中國標準草書學會第十三屆全國標準草書比賽評審。
　　‧典則‧潮風—蔡明讚書藝展（臺北‧國立國父紀念館中山國家畫廊）。
　　‧出版《蔡明讚著作集》六卷（書史、書論、書壇、書家、文房、吟詠）。

典則潮風・蔡明讚現代書藝

發行人 Publisher	**王蘭生** Wang Lan-Sheng	展售處 Shop
藝術家 Artist	**蔡明讚** Tsai Ming-Tzannn	

國家書店—松江門市
10485 臺北市中山區松江路 209 號 1 樓
No.209, Songjiang Rd., Taipei 104,Taiwan (R.O.C.)
Tel / 886-2-25180207　Fax / 886-2-25180778

出版者 Publisher　國立國父紀念館 National Dr. Sun Yat-sen Memorial Hall

110054 臺北市信義區仁愛路 4 段 505 號
No.505, Sec. 4, Ren'ai Rd., Xinyi Dist.,
Taipei 110, Taiwan (R.O.C.)
Tel / 886-2-27588008　Fax / 886-2-27584847
Website / www.yatsen.gov.tw

五南文化廣場—臺中總店
40042 臺中市中區中山路 6 號
No.6, Chung Shan Rd., Taichung 400, Taiwan (R.O.C.)
Tel / 886-4-22260330 Fax / 886-4-22258234
http://www.wunanbooks.com.tw

總編輯 Chief Editor	**楊同慧** Yang Tong-Hui
執行編輯 Executive Editors	**楊得聖** Yang Dei-Sheng **何友齡** Ho Yo-Ling
藝術總監 Art Director	**康志嘉** Kang Chih-Chia
設計總監 Design Director	**王建忠** Wang Chien-Chung
美術設計 Art Designer	**張雅鈞** Chang Ya-Chun
製版印刷 Printing	**意研堂設計事業有限公司**

大手事業有限公司（博愛堂）—國父紀念館門市
11073 臺北市信義區仁愛路四段 505 號
No.505, Sec. 4, Ren'ai Rd., Xinyi Dist., Taipei 110,Taiwan (R.O.C.)
Tel / 886-2-87894640　Fax / 886-2-22187929

Tel / 886-2-89218915　Fax / 886-2-89218917
Eanton Design Co., Ltd.

Bigtom 美國冰淇淋咖啡館—翠湖店
10694 臺北市大安區光復南路 306 號對面
No.306, Guangfu S. Rd.(opposite side) Taipei 106,Taiwan (R.O.C.)
Tel / 886-2-23454213　Fax / 886-2-27238417
http://www.bigtom.us/

政府出版品統一編號 GPN	1011001508
售價 Price	新臺幣 800 元 NTD 800
出版日期 Publication Date	中華民國 110 年 10 月 October, 2021

國家圖書館出版品預行編目（CIP）資料

書象：蔡明讚書藝集 / 楊同慧總編輯 . -- 臺北市：
國立國父紀念館，民 110.10

　面；　公分

ISBN 978-986-532-422-3（精裝）

1. 書法 2. 作品集

943.5　　　　　　　　　　　　　110016773